NO CULTURE,
NO FUTURE

NO CULTURE,

NO FUTURE

SIMON BRAULT

TRANSLATED BY JONATHAN KAPLANSKY

Cormorant Books

**Canada Council
for the Arts**

**Conseil des Arts
du Canada**

ONTARIO ARTS COUNCIL
CONSEIL DES ARTS DE L'ONTARIO

The publisher gratefully acknowledges the support of the Canada Council
for the Arts and the Ontario Arts Council for its publishing program.
We acknowledge the financial support of the Government of Canada
through the Book Publishing Industry Development Program (BPIDP)
for our publishing activities.

We acknowledge the financial support of the Government of Canada,
through the National Translation Program for Book Publishing,
for our translation activities.

LIBRARY AND ARCHIVES CANADA CATALOGUING IN PUBLICATION

Brault, Simon
No culture, no future / Simon Brault; translated by
Jonathan Kaplansky.

Translation of: Le facteur C: l'avenir passe par le culture.
Includes bibliographical references.

ISBN 978-1-897151-76-1

1. Arts and society—Québec (Province).
2. Arts—Economic aspects—Québec (Province).
I. Kaplansky, Jonathan, 1960– II. Title.

Cover art and design: Angel Guerra/Archetype
Interior text design: Tannice Goddard/Soul Oasis Networking
Printer: Transcontinental

Printed and bound in Canada

 Mixed Sources
Product group from well-managed
forests, controlled sources and
recycled wood or fiber
www.fsc.org Cert no. SW-COC-000952
© 1996 Forest Stewardship Council

This book is printed on 100% post-consumer waste recycled paper.

CORMORANT BOOKS INC.
215 SPADINA AVENUE, STUDIO 230, TORONTO, ONTARIO, CANADA M5T 2C7
www.cormorantbooks.com

To Louise Sicuro:

Without you, promoting the access to art and culture for all would not have become such a rewarding way of life for me.

Contents

ACKNOWLEDGEMENTS

I give my heartfelt thanks to Hugo and Philippe Brault, Lucie Cloutier, Benoit Gignac, Rachel Graton, Isabelle Hudon, Anne-Marie Jean, Luc Larochelle, Rachel Martinez, Jordi Pascual, André Provencher, Robert Sirman, and Grace Thrasher; they provided ideas, advice, encouragement, and various forms of assistance.

From the expertise and constant, unwavering support of my first reader, Louise Sicuro, I have benefited greatly.

INTRODUCTION TO THE ENGLISH-LANGUAGE EDITION

Before beginning to write this book, I spoke about my plans to several of my colleagues, both French- and English-speaking. They immediately encouraged me and gave me lots of advice. The advice I received most frequently concerned simultaneous publication in French and English. This was not surprising, as I have worked for almost thirty years in a bilingual national theatre school and am also the Vice-Chair of the Canada Council for the Arts, a position I've held for six years. I, too, wished to have the French and English versions published simultaneously. But things unfolded differently. Today, I am delighted at the prospect of contributing to the discussion of the importance of the arts across Canada, thanks to Jonathan Kaplansky's translation.

When it first appeared in Quebec in September 2009, *Le Facteur C* enjoyed intense and prolonged media interest that neither my Québécois publisher nor I had anticipated. It first attracted attention from journalists and commentators covering

public affairs; their interest in the book confirmed the thesis I articulated: the arts and culture have resonance today that transcends aesthetic issues or special-interest discussions. In interviews, I was given the opportunity to debate economics, urban planning, and public policy — all the while emphasizing the importance of returning to the main ethical, democratic, and humanistic principles required to better understand the essential role the arts play in the human experience.

Journalists specializing in culture and literature read *Le Facteur C* differently than I had imagined when writing it. I had conceived of it as both a testimony and a plea in favour of action to return cultural concerns to the forefront of public policy. It was my description of the urgent need for the greatest number of citizens to take an interest in cultural participation that most caught the attention of the cultural critics, as if they had suddenly realized the situation was imperative. In Canada, we are indeed fortunate; we live in an era with an abundant and constantly renewed supply of artistic works and events. The fact, however, that only a minority of the population — estimated at approximately 30 per cent in most democracies — is interested in or reached by them is disturbing. Even worse, the uneasiness is greater because commercial culture has never done so well, while the culture that is created to elevate the mind, such as the artistic activities supported by the government for entirely legitimate reasons, is marginalized. This cultural life, vibrant as it is, is also at risk each time a government or private patrons reduce the subsidies that culture requires to be economically viable.

Examining the apparent contradiction between the dramatic rise of culture in the public arena and the difficulties and anxieties that affect the sector of arts and letters is at the heart of this book.

I do not claim to have found an infallible way of resolving the contradiction. I am convinced, however, that we must address without delay the issue of attendance at arts events and participation in the arts, thereby expanding access to the most significant works of humanity's cultural heritage, and promoting knowledge and experience of contemporary creation. This is essential for our individual and collective development. I am calling all artists and stakeholders in the cultural sector to action and, above all, I am urging our school systems to take over their students' initiation to the arts, which means exposing them to values I believe are more essential than ever to community life.

I realize I am making remarks grounded in a specific reality that came about through a series of concrete actions, the impact of which is necessarily limited. But I also know how for years I have been inspired by theoretical models and precise accounts of experiences of cultural development emerging from various countries and, more specifically, from some large cities such as Barcelona, Berlin, Lille (France), Newcastle-Gateshead (England), Lyon (France), Toronto, and New York. In this era of globalization, it behooves us not to confuse the need to act locally with a form of localism or regionalism that encourages people to wear blinders when contemplating broad horizons. In this book I speak of Montreal a great deal, but this is to better address issues faced by cities and regions transformed by significant migratory trends and shifts in the world economy. This choice seems to have worked, as reaction to *Le Facteur C* in the English-language press in Canada and abroad demonstrates that the ideas I put forth are significant and resonant: they are now embodied in concrete and sustained action.

Finally, I am eager to receive comments from readers of *No Culture, No Future* because each time I communicate with

readers of *Le Facteur C*, I learn something about their personal relationship to art and culture, the cultural dynamic of their lives, and their dreams and aspirations. I'd bet that English- and French-speaking readers share a large number of concerns and hopes. I know that this is not a risky bet.

Simon Brault

THE NEW CULTURAL IMPERATIVE: A SIGN OF THE TIMES

In recent years, the arts and cultural affairs have increased in importance and visibility in Canada. There has been a marked progression in the number of public declarations emphasizing the importance of them in urban and territorial development. These declarations stem from widely diverse areas: chambers of commerce, economic research institutes, regional development authorities, school boards, band councils, city councils, and the House of Commons.

It is no longer surprising to see culture on the agenda at conferences of economists, sociologists, educators, advertising executives, accountants, urban planners, criminologists, or police officers. Indeed, the cultural angle is valued in broaching topics as varied as tourism, advertising, ecology and sustainable development, the fight against idleness and crime among youth, prevention of school dropouts, integration of immigrants,

requalification of dilapidated neighbourhoods, improvement of intercultural relations in cosmopolitan cities, and affirmation of individual and collective identities.

Furthermore, we see politicians of all allegiances vigorously defending increasing public investment and spending in culture as a strategy. This is particularly evident in cities. For instance, in Quebec City in early April 2009, Mayor Régis Labeaume did not hesitate to suspend debates at City Hall to force the opposition to accept his decision to hire Robert Lepage and Cirque du Soleil, spending millions to provide entertainment for the upcoming five summer seasons in Quebec's capital.[1] They needed to continue the momentum of the four hundredth anniversary, which was successful largely thanks to the shows and artistic creations staged there in the summer of 2008. The city no longer wanted to do without the economic and tourism-related results and the civic pride large cultural events generate.

In Montreal, Mayor Gérald Tremblay chaired *Rendez-vous novembre 2007 — Montréal, Cultural Metropolis*, which ended with adopting an ambitious, ten-year action plan. Nothing was going to prevent him from beginning the work at the construction site of the Place des Festivals in 2008 — not even the fact that the federal and provincial governments were still far from ready to shell out the millions they had promised the strapped metropolis. Culture and politics would henceforth join forces to respond to imperatives on the municipal scene.

In Vancouver, elaborate artistic and cultural programming was devised in anticipation of the Winter 2010 Olympic Games.[2] Governments did not flinch when it came time to sign the required subsidy cheques, and the Olympic torch's long journey across the country was presented as a quasi-cultural event. The

billion TV viewers likely to be amazed not only by our athletes but also by our artists were also proudly and enthusiastically described. The sponsors were on hand.

In Ottawa, throughout the first session of Parliament in 2009, the minority government had to face the fire of the opposition on the cultural front.[3] MPs of the three opposition parties were critical of budget decisions that were undermining Canadian cultural diplomacy, bleeding dry the CBC, and harming international visibility of the country's artists and cultural organizations. Instead of resorting to a credo of rigid fiscal responsibility, however, the Conservatives counterattacked, arguing they were spending more on culture than their predecessors. Their fall 2009 budget, focusing on stimulating economic activity, contained new envelopes destined notably to festivals and artistic training.

Slashing Culture: A Risky Political Wager

It must be said that, since the end of the federal election campaign in the fall of 2008, slashing cultural expenses has been seen as politically more risky than ever. Many political observers argue that the Conservatives missed obtaining a parliamentary majority in the last election partly due to poor communications management regarding the budget reallocations for culture. Were it not for the first terse declarations stigmatizing the poor taste and presumed leftism of subsidized artists and cultural events presented abroad, thanks to the Trade Routes and Prom Art programs, journalists likely would not have been interested in the issue. But they quickly seized the opportunity and interpreted these decisions as confirmation of a hidden agenda advocating moral rectitude and censure. The damage was done even before the election campaign had begun, but when Prime

3

Minister Stephen Harper himself criticized artists who took advantage of subsidized televised galas to express their grievances about budget cuts, his campaign took a nosedive, especially in Quebec.

A new chapter in Canadian election history had been written, debunking a tenacious belief that issues related to the arts and culture only interested a slim percentage of voters and left others indifferent, aggravated, or antagonized. And even if it was in Quebec that the abrupt change was felt most in the polling booths, the lesson deserves its place in political history.

From then on it became wise to incorporate the cultural focus in partisan programs and speeches in order to gain votes in cities, provinces, and in the country itself. This marked a significant change in our political culture.

Arts and Business:
New Partnerships Concluded at a City-wide Level

Awareness of the role culture can play as a lever for furthering development is not limited to politicians, but also extends to economic leaders. In fact, private-sector investments and initiatives for cultural development have increased continually for a decade. In Canada donations to artistic organizations now exceed $200 million annually and sponsorship of cultural events is part of the positioning strategy of almost all large companies.

But it is mainly locally that philanthropy, business decisions, and cultural development meet up, assuming new proportions.

This is the case in Toronto, Canada's economic metropolis, which has had a long-standing reputation for a business-driven environment, but which has recently begun to recognize itself

as a creative city. A handful of patrons and civic leaders have managed to move the Queen City in this direction. Their most spectacular feat was creating a new artistic and urban festival called *Luminato* in 2007. Within a few months, the initiators of *Luminato* managed to amass the funds and support required to launch the event with a budget matching their ambitions. One year after its launch, *Luminato* obtained special assistance to the tune of $15 million from the Ontario government to ensure quality programming by commissioning original works. Equipping themselves with an effective business plan, hiring a competent and motivated leadership team at market value, and having recourse to the effective rhetoric of world-class cities, Toronto's economic leaders created a showcase for contemporary creation. In June 2009, *Luminato* featured original performances by Robert Lepage and Cirque du Soleil. This festival already has the means and branding comparable to events other cities have taken years to achieve under the guidance of artists or cultural entrepreneurs.

The new bond between the world of business and art exists outside metropolitan areas as well. Very recently, in Val-David in the Laurentians, Jacques Dufresne, the owner of a grocery threatened by competition from big box stores, took unusual action to try to save the family business. He accepted the proposal of René Derouin, one of Quebec's most famous visual artists and winner of the Prix Paul-Émile Borduas, to transform the exterior of his building into a living, evolutionary work of art through his murals, which would be covered with climbing plants. In this village, grocery owner and artist joined forces to create a commercially, ecologically, and artistically viable project that has also become a tourist attraction.

A Worldwide Phenomenon

Since 2000 there has been a rise in the number of "creative cities" — cultural capitals and metropolises, either self-proclaimed or designated as such by national or international authorities — in Canada and around the world. This movement began in Great Britain in the early 1990s and was accelerated, and became profitable and cleverly marketed, starting in the United States at the turn of the new century, notably thanks to Professor Richard Florida[4] and his famous Bohemian Index. Intellectualized and enriched by Europeans, this strategy for converting cities into cultural destinations has led to fierce and stimulating competition.

We are seeing dynamic international competition among cities to attract a permanent Cirque du Soleil show, to convince "starchitects" to wave a magic wand over the downtown or the waterfront, to obtain a franchise museum of the Louvre or the Guggenheim Foundation, or to purchase at very high price an original and irresistible urban branding formula. The label "Universal Forum of Cultures,"[5] crafted some years ago by Barcelona, and the better-known "European Capital of Culture" designation have led to civic covetousness of the arts and justify increasingly enormous public and private investment in cities determined to see themselves awarded the honours.

We are more and more convinced that culture attracts, sells, brings people together, entertains, appeals, and impresses. It allows us to bridge the gap between local and international, the specific and the universal. It allows us to exchange and share, counting on the possibility of a dialogue that transcends language and imperfect translations, as well as codes, beliefs, religions, and differences of all manner.

More and more money is invested right now in culture, from all sectors: all levels of government, corporations, and individuals. This is done out of self-interest, but also with determination, pride, ambition, and hope. What used to be desirable or of secondary importance for a city or region has today become imperative; there are studies of side benefits and sophisticated positioning strategies to support this.

Obviously, researchers and academics interested in urban planning, geography, the economy, governance, or cultural policies cannot ignore all these political, financial, and civic movements, or the changes of perspective regarding the importance of the arts and culture. The number of research projects dealing with the intrinsic attributes and direct, indirect, and induced impact of artistic practice, of attending the arts and cultural events and festivals is rising sharply.

Putting Things in Perspective

Where does this sudden craze for arts and culture originate? What are the ins and outs? And what culture are we talking about? Who really stands to profit? Should we be delighted at the new cultural consciousness emerging among our leaders, or disparage manoeuvres that only aim to use culture for purposes that are basely commercial, political, or aimed at attracting tourists and votes? Are politicians' mistrustful reflexes concerning artists about to become a thing of the past? Is the arts and cultural experience subject to exploitation unprecedented in the history of humanity? Is the dream of a genuinely democratizing culture being realized? Have we arrived at the frontier post of a cultural El Dorado, or is it just a trend? Or worse, a flash in the pan?

We must ask ourselves these questions with a clear head and realistically to avoid sinking into the deluded numbness of magical thinking or into paralysis provoked by cynicism and dishonesty.

But the answers we articulate should be qualified. We live in an increasingly complex and changing world. It would be both naive and dangerous to suggest ready-made answers, peremptory explanations, and definitive truths.

The Dawn of a New Era

The arts, culture, and heritage are at the basis of a dynamic and promising sector of activity. They are recognized as an inescapable aspect of a society's development.

The emergence and affirmation of a new cultural imperative is part of an international trend. It is largely the result of artistic, cultural, political, and civic leaders taking concrete action on a countrywide scale and, increasingly, in large cities, the new nerve centres of the economy and social development.

Everyone can participate in this movement to bring culture back to the heart of human experience. At a time when our only option is to think about the future of a civilization threatened by self-destruction, the consequences of this movement become even more significant. Battles for culture, education, the environment, peace, and social justice appear essential to re-establish the balance upset by the unchecked greed.

I decided to write this book to share thoughts and analyses linked to my experience as CEO of the National Theatre School of Canada, one of the country's top centres for training professional artists, and above all, to the daily commitment I've carried out for

fifteen years to favour cultural democratization and bring the arts to the heart of urban development.

Trying to avoid inundating the reader with figures and statistical data, I use some quotations to support my reasoning, but do not give a critical review of what is written and being done in the field: I leave that to the scholars. Rather, I rely on my experience in and knowledge of a field I have been working in for several years. At times I describe actions I have taken, not to claim credit, but to support my arguments.

Witnessing in Three Acts

This essay is divided into three parts. The first deals with culture as a sector of activity. I address the question of its economic impact, but also discuss certain aspects specific to its evolution, such as funding, artists' conditions, and the structuring role of cultural policies.

The second section deals with culture as a dimension of our personal and collective lives. I deal with supply, demand, and cultural participation. I also state that in the coming years we will have to revise the cultural equation in favour of the greater number to avoid the collapse of the current model based on supply.

The third part of this book describes the attempts to place the transformational power of the arts and culture in Montreal, one of our major cities, which has been reconfigured and reconstructed by immigration over the last two decades.

My conclusion deals with the urgency of tackling "re-enchantment" of the world as the curtain falls on the first decade of the twenty-first century, and the jury is still out on the future of our civilization.

Throughout the book I will seek, with the reader's co-operation, to assemble the scattered pieces of a puzzle: its still-hazy image indicates the prospect of a winding but negotiable road to a better future.

CULTURE AS A FORWARD-LOOKING SECTOR FOR THE FUTURE

Culture is not a parasite of economic and social development, but can be a motor for it. The possibilities the cultural sector holds arouse keen interest from regions and cities. Increasingly, these possibilities motivate decisions originating from a socio-economic rather than purely cultural logic. Artists are concerned with their creative freedom, faced with what could be an immense takeover and exploitation. They also wonder if their own lot will improve, given this shift. As for the public, it is still not too concerned about these changes in perspective.

Culture, What Culture?

Sometimes we have to leave our comfort zone to realize that the words we use every day with our colleagues do not mean the same thing in another context and on another scale, a truth that really hit home for me one afternoon in the spring of 1997.

I was participating with some colleagues from the cultural community at a brainstorming meeting in the offices of one of Montreal's most renowned advertising agencies. The agency had just agreed to help us create the logo, corporate signature, and first communications campaign of an event we wanted to launch the following autumn: the *Journées nationales de la culture*. The venture was so close to our hearts that we had already devoted to it months of intense advocacy and promotion, over and above our respective professional occupations.

The agency's owner, accompanied by a few members of his creative team, began the meeting by welcoming us. Then he asked us to explain our project's philosophy and describe how we wished to set it in motion. Speaking on behalf of the group, I broadly summarized the difficulties and limitations of our cultural policies. Too many fellow citizens still didn't have access to the arts and local cultural events, except through the medium of television, which offers often questionable choices. This is due to economic barriers, persistent weaknesses in the education system, geographical distance of places where works are presented, and insufficient investment and effort to develop cultural participation. The inalienable right to culture that justifies government involvement often remains theoretical. I commented on the dangers of a subsidized cultural system that only encourages excellence and a wide array of artistic production to the point of almost forgetting to develop the demand. The great principles of cultural democracy had to be brought back to the forefront, and quickly. We would encourage citizens to meet, without cost and in a friendly setting, artists at work in their studios, workshops, or rehearsal rooms. We thought that for once we must turn the spotlight on the creative process and not just on the final product.

I concluded my speech, thanking them for providing their expertise in communications for an event to sensitize people to culture that would arise from Quebec's cultural sector and bring all disciplines together. I announced that we were lucky to be able to count on a wonderful volunteer spokesperson, respected in the artistic community, known and liked by the general public in Quebec. This actor, Marcel Sabourin, has performed for decades in children's programs, movies, theatre, and popular drama series, wrote several songs that Robert Charlebois made popular, and is a top trainer with the Ligue nationale d'improvisation. His reputation and eloquence would allow him to embody the values we wished the event to promote.

Marcel Sabourin then spoke, declaring immediately that creation is the driving force of life. He emphasized that it is not, nor should it be, the exclusive property of professional artists. He compared it to a little flame that lives in each of our hearts. One needs only to blow on the flame to fire up the imagination. He spoke of his mother, his childhood, and his path as an artist who has explored several disciplines. His actor's voice, sonorous and warm, filled the room. His emphatic gestures hypnotized. His unbridled imagination and propensity for powerful metaphors set our intellect in rapid motion. He ended his passionate plea by saying it was an honour and a duty for him to help launch these *Journéees nationales de la culture.*

Marcel's talk was uplifting. The people seated around the table were attentive and open. There was energy in the air, until the advertising agency's owner, Michel Ostiguy, intentionally placed a fly in the ointment. He lit another cigarette — in 1997 people could still smoke in meeting rooms — and smiled. Then he asked us point-blank if we would be willing to modify the name of our

event. We replied it would be awkward; indeed, we hoped that soon a motion would be passed in Quebec National Assembly declaring that the *Journées nationales de la culture* would be held each year on the last Friday of September and the two days that follow.[6]

Far from becoming disconcerted by our answer, our host continued to smile sympathetically, although he did look prepared to press his point. Intrigued, we asked him to explain his thinking. He replied that in his humble opinion two words in the event's name would cause a serious problem if we intended to reach the general public: the words *national* and *culture*.

First, *national* — a word that in Francophone Quebec is associated with *governmental*. After discussion, we came around to the idea of eliminating it from the name of the projected event. We would have to notify the people we already consulted in the cultural community, and moreover inform the then-Minister of Culture, Louise Beaudoin,[7] who had wholeheartedly supported and understood the project from the start. In fact, she would decide to include the *Journées* in the first *Politique de diffusion des arts de la scène* (a policy supporting the presentation of a diverse range of performing arts across the province), which she was developing. The policy would be called *Remettre l'art au monde* ("Giving art back to the people"). More than a pretty title, it was an ambitious program and a generous promise, even if the ways of carrying it out were yet to be fully developed.

Culture is a word with elitist connotations that turns people off — one to avoid in an advertising campaign. What a letdown: we had entered this room galvanized, wanting to bring the cause of cultural democratization to the forefront, and now we were facing a marketing expert who strongly suggested we not use the word.

"But why are you so anxious to use the word *culture*? What is culture, anyway? Who's interested in it except for theatre, modern dance, and classical music buffs? True, the word *culture* sounds less elitist than the word *art*, but still! Do you really want to attract people or do you wish to please yourselves?" The debate was lively; ideas and reactions came from all sides. Our convictions and intuitions were put to the test. We searched and explored.

But a decision had to be made. We decided to keep the word *culture*.

We understood that the word — even if we avoided adding adjectives such as *classic*, *high*, or *great*, to it — inevitably refers to art and works that are less popular. The challenge would be to ensure the greatest number of people understood the word so as to be conscious of perceiving a reality that could become more familiar, less distant. Culture must be a part of daily life and stop being seen as an activity reserved for the initiated. We had to be inclusive. Most of all, the invitation had to be launched directly by the stakeholders in the cultural sector and not by the government. The Bos Agency agreed to help us meet this challenge by creating the first advertising campaign for the *Journées de la culture*.[8]

Promoting the Idea of Culture for All

As of early September 1997, the marquees and the facades of theatres, libraries, museums, artists' studios and workshops, and cultural and community centres in approximately one hundred municipalities across Quebec were decked out in the colours of the *Journées de la culture*. The advertising slogan read, "Ça manquait a notre culture," an adaptation of a vernacular expression which could be loosely translated as "What our culture lacks." We

printed 1.2 million copies of the program, which were distributed in eleven of the province's daily newspapers. In a press conference, Marcel Sabourin declared, "The *Journées de la culture* exclude nothing and no one. No one is unwelcome based on origins, financial difficulty, or distance. By joining forces in this event, the cultural community proves that the desire for solidarity transcends other concerns. For if ever there were some place, hidden, beside you, in your home, a Picasso, a Molière, a Borduas, a Félix Leclerc, or even a Lao-Tsu who suddenly became inflamed ... [you would realize that] culture is like happiness: you only notice how important it is when you don't have it." The advertisement, broadcast free on all TV and radio stations, featured Marcel Sabourin explaining to what extent culture informs and enriches our daily lives. He recalled a love song a mother sings to her child and the beauty of the design of a simple fork. More than 150,000 citizens took part in some six hundred free activities offered during the *Journées*, organized with all the enthusiasm of a premiere. The event was launched. A collective effort for access to culture was organized across the province, a fundamental movement was set in motion. In years to come, the number of activities offered for the *Journées de la culture* would double, and then triple. The number of participants would grow exponentially from one year to the next.[9]

I often think back to that meeting in the trendy offices of the advertising agency then located on boulevard Saint-Laurent. That brainstorming session made me realize the power of our words and of our convictions. I realized how marginalized art and the cultural scene were and what an immense challenge lay ahead of us. We wanted to legitimize a cultural sector unable to develop and sustain itself in so small a market without government support.

This could not be attained simply by selling more tickets for shows or collecting more museum admission fees. We faced issues greater than marketing or collecting attendance statistics. We had to promote a utopia just as essential to our community life as the idea of justice: culture for all.

By conferring with informed and creative people familiar with the workings of a system based on sales and consumption of products, commodities and services, I realized how much we had to sift through the mountains of received ideas in order to make progress. Good intentions and the refusal to remain in our ivory tower were not enough. We had to formulate clear, forceful arguments; we had to communicate imaginatively and effectively, and we had to explain and defend our democratic principles from all platforms. As repetition is a fundamental aspect of all pedagogy, we were not afraid of reiterating certain points. When the time came to launch the *Journées de la culture*, we could not become intimidated by the polite indifference or barely contained hostility we sometimes encountered amongst our own colleagues. In fact, several people claimed that democratization was tantamount to seeking the lowest common denominator. We had to convince them otherwise. The quest for excellence and improvement of artists' living and working conditions should no longer be separate from a collective action to promote access to the great feast prepared each season with the support of taxes paid by citizens.

By launching these *Journées*, we decided to call a spade a spade. The word *culture* was no longer to be avoided. It was good for culture to come down from its pedestal and to walk with open arms in the streets of Quebec's cities and towns.

A Word Whose Meaning Can Shift

Let's look at the definition of the word *culture* for a moment, not in an attempt to settle a debate grown complex with the incalculable number of philosophers and other intellectuals who have joined in it over the last hundred years, but to explain what I mean in the context of this book.

I am not particularly fond of definitions, but am drawn to a sufficiently open and inclusive one that does not dismiss art, knowledge, scientific culture, and popular culture, all of which interpenetrate and influence each another. The United Nations Educational, Scientific, and Cultural Organization (UNESCO) is the accepted authority when it comes to explaining the larger meaning of the word *culture*. It presents it as "the set of distinctive spiritual, material, intellectual and emotional features of society or a social group, and that it encompasses, in addition to art and literature, lifestyles, ways of living together, value systems, traditions and beliefs."[10]

Sociologist Guy Rocher's definition is along the same lines, emphasizing even more clearly the collective aspect of the phenomenon. He describes culture as a "more or less formalized connected set of ways of thinking, feeling, and acting that, learned and shared by a plurality of people, objectively and symbolically makes these people into a specific and distinct collectivity."[11]

In this first part of the book, I nevertheless use a much more specific sense of the word *culture*. Unless indicated to the contrary, I include in my definition of culture: 1. arts and letters (performing arts, literature, visual arts, media arts, etc.); 2. cultural industries (movies, publishing, radio and television, design, etc.); 3. heritage (buildings, landscapes, oral traditions, memorial sites, etc.).

Of course, there are no impenetrable boundaries between the

arts, cultural industries, and heritage. Nor are there prescribed economic models, even if, as a general rule, we may associate arts and letters with the not-for-profit sector and cultural industries as seeking profit, while activities connected to heritage are part of a hybrid economic model.

Acceptance of this more precise definition of the word *culture* is useful in speaking of a sector of activity with its practices, organizations, associations and unions, mechanisms for production and dissemination, jobs, and economic repercussions.

A more philosophical definition of the word *culture* would allow me to speak of a "dimension of life" with its values, individual and social impacts, applications in urban planning and education, etc. I will focus on this in part two.

Culture does not escape economics. It even plays a major role, although economists and cultural advocates do not always agree when it comes to quantifying and qualifying it.

Despite the remarkable progress made for a few decades now, which gives them increasing legitimacy, the link between economics and culture still remain dubious for many. Discomfort persists both in the ranks of artists and in economic circles.

Culture and Economics: A Modern Couple

The complicated (to say the least) relationship that has existed for some years between culture and economics still causes a lot of ink and a lot of talk. The two are closely observed, and carefully analysed. People comment profusely on their successes and fear their failures. But we also note that their relationship survives the lean times that invariably follow more prosperous ones. We try to understand the specific chemistry that brings them together. We

worry, seeing them argue in public, and then are moved by their reconciliations, often given media coverage.

Economics and culture make a modern couple, one very visible and thus envied. Some take umbrage at the attention given to them. But pundits and politicians alike freely admit we can no longer do without them. I confess I have been associating with them faithfully for twenty years now. When I met them, their relationship bothered me because it seemed unequal. But I got to know them and have observed a marked improvement in their relationship over the last ten years or so. Of course, I hear all sorts of things regarding the current state of their relationship: suspicion, praise, and exaggeration. People speak about them too much behind their backs. The rich and influential friends of economics sometimes are condescending to culture, as if its social status depended only on its relationship with economics. Close friends of culture often demonstrate complacency. They hope, without admitting it, that a lasting association with this couple will finally open to them the doors of the social ladder and serve their own interests.

The conversation is perhaps biased to one side or the other, but the subject is never exhausted; speaking of economics and culture leads us to consider the results of their necessary relationship, both in periods of prosperity and when solutions must be found to offset the effects of a global financial crisis. I will discuss this later when comparing the cost of creating and maintaining cultural jobs with similar costs in the manufacturing sector when it is in a state of collapse.

We have an idea of the opinions circulating. The stage is set to continue the discussion by throwing out some intentionally provocative questions.

Should we defend and justify the importance of culture based on its economic impact? Is there a danger of subjecting art and culture to the changeable imperatives of economic development? Can the economy of the twenty-first century do without the contribution of artists and the vibrancy of the cultural sector?

The Ups and Downs of the Economic Argument

In Canada, as in all countries, people recognize the commercial success of many homegrown companies, such as Cirque du Soleil, Indigo Books & Music, Archambault, l'Équipe Spectra, and the Just for Laughs group. We also recognize the achievements of artists such as Luc Plamondon, Margaret Atwood, Robert Lepage, Denys Arcand, Karen Kain, Atom Egoyan, Arcade Fire, and Michel Tremblay. But we tend to consider these successes as exceptions that confirm the rule: in general, the cultural sector is characterized by poverty, precariousness, and dependence on the public purse. Although diminishing for some years, prejudices and skepticism about the real economic value of the cultural sector, especially the arts, persist. These perceptions are not exclusive to one political affiliation. I have observed this over several years, pleading the cause of public arts funding before major political parties — Liberals, New Democrats, and Conservatives as well as the Parti Québécois — at the provincial and federal level, in majority or minority governments, in times of budgetary surpluses and in times of budgetary deficits. Prejudices about the economic contribution of the arts are not easily swayed by the flood of abundant statistics that have been rained down upon us for a few years. The mood of political decision-makers remains uneven when it comes to recognizing the economic potential of the cultural sector. This volatility explains several incongruities.

It is therefore not surprising that several representatives and advocates of the arts dreamed of having a complete, persuasive, and definitive economic argument. It would be a miracle if a consultant in the shining armour of credibility handed them the magic report irrefutably demonstrating the validity and relevance of investment in the arts and culture. Then all the cultural sector would have to do would be to distribute copies of such a report to government departments and boardrooms of large companies to open the floodgates of adequate and legitimate financing. But this fantasy will not come to pass, not immediately in any case, and things are never so simple.

Indeed, let us first remember that economics is not an exact science. There are almost as many theories, approaches, models, hypotheses, and significant nuances as there are economists. Besides, politicians, civil servants, leaders of institutions, and cultural managers often interpret, support, and distribute them based on their current interests.

We must also temper our impatience with people who are skeptical of the economic role of the arts and culture, and remember that creation, production, and conservation of art and access to it were almost entirely absent from the discourse in the economic sphere until very recently. In fact, it was only when cultural industries of film and television production, sound recording, and book and magazine publishing generated the phenomenon of mass cultural consumption that we saw the framework of an economic sector worth studying, the economic weight of which could be assessed.

We should also acknowledge that certain trends of thought contribute to erase or confuse relationships between art, culture,

and economics. I am thinking here of the romantic vision of Bohemia and the exaggerated interpretations of an "art for art's sake" ideal where artists are unaccountable and disconnected from society. I am also thinking of the variants on American show business mythology that reduce the issues to the flashy success or abysmal decline of a few stars.

We cannot remain silent about the damage wreaked by high society's snobbishness or the intelligentsia's elitism that see culture as an enclosed and privileged hunting ground unaffected by economic and social change.

Artists and cultural organizations often resist the idea of presenting their contribution to society from the point of view of economics, afraid of seeing their activities misrepresented or narrowly assessed in terms of mere profitability. This mistrust is actually fed by attempts to establish a mechanical cause and effect relationship between artistic and cultural events and precise economic consequences. Of course, we can maintain that organizing free concerts in a city's downtown stimulates commercial consumption. Just walk around the site of the Montreal International Jazz Festival or try to reserve a hotel room in downtown Toronto during the Toronto International Film Festival. But going from there to asking artists to create projects to make restaurants, merchants, and hotel owners happy is a bridge not to be crossed.

Unquestionably, the arts and culture sector needs less economic validation than the twenty-first century's economy needs artists' creative contributions. The arts and culture affect the economy both directly and indirectly; in certain conditions, they are a powerful economic engine. But their *raison d'être* is not and will never be limited to economic activity and growth.

Rankings Can Be a Trap

Ann Daly,[12] an arts consultant, lives in Austin, the Texas city classified by Richard Florida in 2006 as the premier American city in terms of creativity. Aptly, she wonders if Austin's artists and cultural institutions today are objectively in a better position than before the guru of urban creativity's list of winners was published. She maintains that the argument on culture's economic impact is very useful to defend a given project, but is certainly not a magic bullet or effective in the long run in furthering cultural development.

In this city, held up as an example by so many city councillors throughout North America, artists, business people, and politicians are beginning to say aloud that their city's cultural energy and creative explosion are not only necessary and useful to the economy, but shape its identity and its way of presenting itself to the world.

In the City of Austin's cultural development plan adopted in 2008,[13] we of course find a list of the cultural sector's direct economic impacts. But it is striking that the city's arts and culture are spoken of in almost poetic terms, presented as being at the base of a both beautiful and fragile ecosystem to cherish and protect.

Served up repeatedly and in large doses, economic rhetoric probably results in wearying people. It can certainly capture the attention of some audiences, but sooner or later must lead to greater considerations. We must appeal not only to the mind, but also to hearts and souls.

That doesn't mean it is futile to advocate the cultural sector's direct and indirect economic importance; not to do so would be all the more dangerous, as we live in a time when the economy is

an indispensable factor for political decision-makers, and when culture is also a constant political issue.

What is Counted Ends Up by Counting

There is still no standardized definition of the cultural sector on a global scale, which complicates comparisons of cultural statistics between cities regions, and countries.

Despite these inconsistencies, we can define several complex and shifting realities that cover the concepts of the arts, culture, or heritage in various contexts. By searching a bit, we find data and detailed descriptions compiled and analyzed by many cultural observers on different scales as to how the media, recording, and publishing industries work. This field of knowledge has been developing intensively for some years now.

The problems of quantitatively measuring the cultural economy will no doubt persist, but should not serve as an excuse for denying the obvious: the cultural sector exists and generates an increasingly significant part of the Gross Domestic Product in developed countries.

It is difficult here to avoid mentioning Canadian statistics most often quoted in claiming that "culture is serious business."

According to Statistics Canada, more than 609,000 direct jobs existed in Canada's cultural sector in 2005, representing 3.3 per cent of all employment. More than 64 per cent of these jobs were concentrated in the three large metropolitan regions of Toronto, Montreal, and Vancouver.

In a report titled *Valuing Our Culture*[14] published in 2008, the Conference Board of Canada claimed that direct, indirect, and secondary contributions of the cultural sector are responsible for at least 1.1 million jobs in the Canadian economy. If we add to

this estimate the 729,000 volunteers[15] who support the cultural sector as members of boards of directors, workers in libraries, or guides in museums, we observe that two million Canadians have an occupation, paid or not, that depends on culture and contributes to its economy.

We are also told that in 2004 revenues from tourism in Canada reached $57.5 billion and that 7 per cent of these expenses were directly linked to the cultural sector. For example, an estimated 40 per cent of the 7.5 million tourists took part in at least one cultural event.

In 2007, exports of cultural products reached a little under $5 billion, 1 per cent of our entire exports. The value of our cultural exports is sharply on the rise as it has increased by 80 per cent in less than a decade. Moreover, this growth could persist if the federal government decides to show more interest in it. For Quebec, the issue is significant as it exports a great deal more cultural goods than it imports, as opposed to Ontario.[16]

Citizens are also spending more and more on culture. In 2005, Canadian consumers' cultural expenses were 5 per cent higher than their overall expenses on furniture, household appliances, and tools. Although the lion's share went to home entertainment equipment and reading, expenses for performing arts reached $1.2 billion and are now 2.2 times greater than for sporting events. The $25.1 billion spent in 2005 by Canadian consumers on culture represents more than three times that spent by all levels of government on culture — $7.7 billion in 2003-2004.[17] Hill Strategies Research[18] concludes that expenses for cultural goods and services increased by 25 per cent between 1997 and 2005, accounting for inflation, while demographic growth was less than 8 per cent. In analyzing the data available up until 2007, the

Conference Board of Canada concluded that the growth of real government expenditures on the arts and culture over the course of the last decade were, at most, synchronized with that of their expenses for buying goods and services, no more. Only the Government of Quebec is seen as an exception.[19]

The Conference Board also claims that the real economic footprint of the cultural sector in Canada had a value of $84.6 billion in 2007, which then represented approximately 7.4 per cent of the GDP. They based this estimate on the framework for cultural statistics created by Statistics Canada.[20] Defining culture as an economic sector encompasses written media, film, broadcasting, sound recording and music publishing, live entertainment, visual arts, handicrafts, photography, libraries, archives, museums, art galleries, advertising, architecture, design, without excluding government support for culture and activities of cultural associations and unions.

But while we are still looking to assess the portion of the GDP directly attributable to activities of the cultural sector as precisely as possible, we are also increasingly interested in the economic impact of culture locally, and with good reason. Politicians are elected locally, and countless business and consumer decisions are made locally as well.

Tangible Consequences Locally

We already know that having cultural institutions and holding cultural activities contribute to the local economy by encouraging local consumption (restaurants, hotel, retail sales, etc.). But the cultural sector also has palpable and durable impact in terms of jobs, a consideration worth its weight in gold in our era.

Doubtless this is what prompted the Americans for the Arts

Association, one of the most articulate and best organized cultural lobbying groups in the world, to publish on its website in 2007 the "Arts & Economic Prosperity Calculator."[21] This easy-to-use tool, designed by renowned economists, allows users to estimate the impact of a not-for-profit cultural organization on the economy of a given city.

Taking into account the population of a city or community, we may evaluate the consequences of each block of $100,000 cultural organizations spend in terms of jobs, average household income, and fiscal consequences for various levels of government. For example, we can establish that an organization that spends $250,000 in a city with a population between 250,000 and 499,000 supports an average of 7.5 full time jobs locally.

With the same tool, we can also calculate the impact of public spending by people who attend cultural events. Excluding the cost of the ticket or admission fee, but taking into account average expenses in terms of transportation, restaurants, babysitting, and other such expenses, we estimate that a theatre built in a city of 300,000 inhabitants and that has 25,000 admissions a year supports 17.6 full time jobs in its community.

Compare this information with the expenditures made in 2009 by the American and Canadian governments to maintain jobs in the automobile sector, which was then undergoing a meltdown: approximately $2 million of public money per worker. The attempts to save jobs in traditional sectors, such as those in the automobile or forestry industry, require governments to inject billions of dollars.

Yet between 1991 and 2005, the sector encompassing the arts, culture, sports, and recreation ranked second in terms of job growth in Canada. The odds are this performance will continue despite

the current economic crisis. It is high time we take note of the cultural sector's contribution in terms of creating and maintaining quality jobs and act accordingly.

Avoiding Diehard Economism

There is still much research to be done to understand the correlations between creating, producing, providing access to, and exporting cultural goods and activities, as well as the various aspects of economic development of urban centres, regions, and countries. Fortunately, many researchers from all disciplines and schools of thought are enthusiastically doing so. We must be careful not to jump to hasty conclusions that could benefit one or another of the various opposing forces.

The argument that the cultural sector's role will constantly expand in the twenty-first century's economy is promising. For artists and cultural institutions, the argument of the increasing significance of their sector makes obtaining better public and private funding easier. For the ministries and agencies that subsidize culture, the economic argument allows for alliances with other ministries responsible for government mission and therefore provides access to additional resources. For citizens, it may be worthwhile, because sometimes it translates into building new means of accessing culture, such as theatres, libraries, and museums.

In my opinion, however, a one-dimensional and instrumental approach that would only justify or value artistic creation solely where it has calculable economic impact would be immensely more devastating for our society than underestimating the cultural sector's economic contribution.

We still need, perhaps more than ever, public policies and instruments for regulating, protecting, and supporting the arts

and artistic, cultural, and heritage activities that stem from democratic, educational, and social concerns and are not always linked to economic objectives or priorities.

Funding of the Cultural Sector in Canada: Myths and Realities

We hear a great deal about funding problems in the cultural sector, just as we hear about the lack of resources in the health and education sectors, but it should be recognized that myths are easier to spread and perpetuate when it comes to arts and culture.

The combined cultural expenses of the three levels of government (municipal, provincial, federal) reached $8.23 billion in 2006–2007.[22] This is an impressive figure in itself, but is modest when compared to the $84.6 billion in GDP attributable to the cultural sector according to the Conference Board's estimate. The leverage effect of public expenditures in culture allows us to compare them advantageously to the same effect of governments' support for other sectors.

It should be remembered that approximately 45 per cent of public expenditures in culture in Canada are incurred by the federal government, 30 per cent by the provinces, and the rest by municipal administrations.

Another point to remember is that 61.1 per cent of total federal expenses in the area of culture in 2006–2007 served to support the cultural industries. Close to half of these expenses were for radio and television broadcasting. Moreover, 25.6 per cent of the amounts were allocated to heritage, which includes museums, public archives, historic and natural parks as well as historical sites. The third sector in terms of importance was that of the arts

(which includes performing arts, arts education, visual arts, and handicrafts). Therefore just over 7 per cent of total federal cultural expenses in 2006–2007 went directly to the arts.

Provincial and territorial administrations allocate 37 per cent of their total cultural expenditures to libraries and close to 27 per cent to heritage.[23] As in the federal government, the performing arts (theatre, dance, music, etc.) capture the lion's share of expenses to support the arts. Quebec grants more money by far to culture in Canada than any other province: its expenses per capita are three times greater than those of Ontario or British Columbia.

Public libraries receive 71.5 per cent of municipal expenditures in culture.

We must remember that public funding, in all its forms, makes up only one of the sources of revenue for the cultural sector; the other sources include income from the sales of tickets and books, for example, as well as advertising income and commercial sponsorship. A host of incomes linked to use of facilities and the sale of ancillary cultural products to raise revenues also enter into the equation (museum shops, restaurants in theatres, room rentals, etc.). Finally, not-for-profit cultural organizations also receive private gifts from individuals, foundations, and companies.

The equilibrium between the different sources of income is influenced by a variety of factors, including artistic discipline, profile of a company, and its specific location within a city or a region. The situation is also true when we make comparisons between arts organizations among different countries. In all cases, the cultural sector enjoys a wide range of revenue in addition to those paid directly by all levels of government.

Undeniably, there would be no cultural sector worthy of that name in Canada were it not for the conscious, deliberate, and

sustained action of governments. This applies to the stream of arts and letters, which could not survive in the same conditions without government grants, and it applies, perhaps even more, to cultural industries that benefit from a set of rules, control mechanisms, and tools put in place by governments, such as the Canadian Radio-Television and Telecommunications Commission (CRTC), Canadian content quota, tariff policies, public funding corporations, tax credits, and regulations on the exportation of Canadian cultural property.

At a time when certain owners of companies that today control the large private broadcasting networks in Canada are demanding individual deregulating on a case-by-case basis that would help them to expand immediately, it is relevant to point out that their empires would probably not exist had they not been able to benefit from these same government created and enforced regulations in the past. In addition to benefiting from regulations, these companies are able to call upon the talent of creators working in the not-for-profit and government subsidized system based on artistic criteria of excellence. In Canada, as in France, Italy, Germany, and elsewhere, these companies have been able to benefit from a national cultural field protected by public policy; arguably, they have been able to develop and grow impressively because of regulation. By wanting it both ways, they seem to forget that they benefited more than they suffered from cultural policies and regulation.

That said, Canada's cultural industries are facing enormous and worrisome challenges. The traditional business model prevailing for more than a half century is being shaken up by the combined effect of globalization and the rapid evolution of technology. While as consumers we are more familiar with the

upheaval affecting the recording industry in the era of iTunes and music downloading, we should know that only represents the tip of the iceberg.

We should not forget that in such a context the most independent, risky, original, specialized, and diverse areas of creation are threatened, thereby limiting artistic expression in favour of a cultural marketplace more economically viable. Independent film, television programs dealing with the arts, and literary magazines are placed in jeopardy by the struggles of industry titans, even as these stagger beneath the pounding of the competition.

The planet-wide concern for diversity of cultural expression must be articulated within nations and their respective cultural industries. The arguments put forth internationally to protect this diversity must be updated and used domestically.

The Unacceptable Conditions of Artists

Artists are at the foundations and heart of the cultural sector. They create content, and they interpret and perform works of current creators as well as those creators who came before; it is these individuals who make up humanity's artistic and cultural heritage. Without artists, the cultural system would be nowhere.

Obviously, artists play a role in society, one that transcends the boundaries of the cultural sector. Artist-creators are constantly exploring the human psyche and our relationship to nature, to each other, and to ourselves. They are adventurous, and take off without warning for territories not yet familiar to us, returning with words, images, movements, and sounds that fascinate, concern, question, disturb, reveal, fill us with wonder, or prepare us for changes in how we perceive things, if not actual

social changes. Creators are exceptional human beings who are intuitive and have rare talent. They add their contribution to the immense, constantly evolving construction that is humanity.

Artists who devote themselves to performing seek to attain levels of truth, sincerity, and virtuosity that allow them to breathe powerful life into artistic works. The best of them continue to study, train, and seek in order to interest, captivate, and move their contemporaries.

Societies need their artists so they have access to artistic works that explore the human condition at its darkest and most tragic recesses, but also at its most luminous, comic, or ecstatic. I am not attempting to glorify professional artists to an extreme degree, but I am trying to express how essential it is that some of our fellow citizens devote themselves full-time to art, to satisfy not their own desire for expression, but to reflect our own, and to pose questions and suggest answers to our current existential and social questions.

To be an artist is thus both to carry out a profession and to assume a destiny linked to creation. Yet when people mention artists' conditions, generally they refer to the first aspect and discuss conditions in which the artistic profession is carried out. The cultural sector is first and foremost interested in artists as professionals who create or perform. It recognizes them and remunerates them for their productive activity.

The population, as a general rule, does not know what is negotiated in the wings of a sector that would be barren without the artists' contributions. Appearances are more misleading here than elsewhere. Artists' complaints about their economic situation, sometimes echoed by the media, are often perceived as

frustrated and disappointed expressions of artists who are less successful or who do not find work.

But how do we treat artists in the beginning of the twenty-first century, when the importance of culture seems increasingly to meet with the approval of economic decision-makers and private and public spending on culture is higher than ever? Generally speaking, we treat them poorly, and we do so on two fronts: in terms of remuneration when they carry out their professions, and, perhaps more importantly, in not valuing their broader contributions to our society. Too great a number of poets, musicians, and dancers live below the poverty level when they devote themselves only to their art; on top of that we deny their social usefulness. I will return to the issue of recognition of artists and art in part two of this book, but let us linger for another moment on the economic condition of artists as professionals. In Canada, as in most wealthy countries, artists' incomes are variable throughout individual careers; moreover, they are distributed unevenly. Pareto's Law prevails: 20 per cent of individuals earn 80 per cent of the revenues in the sector. We also often encounter situations where artists' incomes are negative, because the cost of carrying out an artistic activity is higher than the income it generates.

I will spare the reader the detailed statistics describing the situation of the approximately 142,000 professional artists in Canada, but urge you to consult the profile created by Hill Strategies Research based on data from the 2006 census.[24] There we find confirmation that despite their high level of training and often unlimited personal commitment in developing their skills, our artists are very poorly paid for their work. In Ontario, the gap

between artists' average income and that of the total active population is 38 per cent. In all other provinces except Quebec this gap is 40 per cent or more. Quebec remains the province where the gap is smallest in Canada, at 25 per cent.

This statistical profile confirms in every respect that a huge gap exists between the importance granted to culture in economic and political leaders' speeches and the improvement of artists' economic conditions in Canada.

I could provide many additional details to the portrait arts organizations, associations, and unions paint regularly, but this would be at the risk of dwelling on the discouraging, even sordid, side of life. In fact, I know several artists who earn a very good living and are in such demand they have to refuse offers. Some among them are known by the greater public and several others work in the shadows as designers and writers. They live well from their fees, residuals, or royalties, but they know they are only the peak in a pyramid of income in the artistic community. They belong to the minority, as only 20 per cent of artists earn more than $50,000 a year.[25] From time to time, I see graduates who obtain quite lucrative contracts upon leaving the National Theatre School, while many others, with just as good training and just as much talent, take years before they are able to live well from their art. There are many variables, often imperceptible, that enter into this, and fees offered artists differ a great deal depending on whether they work in the cultural industries or in the not-for-profit, subsidized arts.

Generally speaking, fees and royalties paid in the cultural industries are a lot higher than in the arts and letters. In industry, the ultimate sanction is the market. Remuneration takes into account consumers' attitudes to cultural products. Sales figures and

ratings establish levels of pay that may be high. Ask designers and directors who receive their share of the tens of millions of dollars paid out by Cirque du Soleil in residuals![26]

Having said this, I hasten to point out that all is far from rosy in the cultural industries. As French sociologist Pierre-Michel Menger[27] explains, the differences in remuneration are not only tolerated, but also required and even applauded. These marked differences are largely the result of arbitrary distinction and evaluation made by the general public.

Creators' intellectual rights must often be fiercely defended and the attitude that artists are disposable, widespread in some production houses, exposes artists to the arbitrary. Finally, we note that certain intermediaries who make the wheel of industry turn are much better remunerated than artists.

In terms of subsidized arts and letters, the work is judged based on agreed-upon aesthetic, artistic, organizational, and administrative criteria that regulate the process. The opinion of peers selected and gathered together by arts councils is certainly not exempt from prejudice, but without a doubt is the least objectionable system for evaluating artistic merit of individual projects and programming cultural organizations.

Obviously, the public and the critics also have their say, but their direct impact upon the treatment of artists is marginal. The artistic world functions relatively autonomously in respect to the marketplace when it comes to remunerating artists, although there are exceptions. Thus, when we call upon artists already known in the stream of cultural industries — stars — sometimes they are paid higher fees. Producers, directors, and other persons making hiring decisions cite their ability to attract a larger public to justify such preferential treatment. Very specialized markets

also exist, which push up remuneration of certain artists, such as internationally renowned opera singers or musicians, that the most prestigious symphonic orchestras compete to get. There is also a very narrow and highly favoured area when it comes to remuneration: here we find some orchestra conductors, the rare superstars of contemporary art, and stage directors of world calibre. But of course this concerns only a minority and the fate of these individuals has little impact on statistics portraying the conditions of artists in Canada.

As a general rule, remuneration in the sector of arts and letters is less than modest, and jobs, except in institutions, are temporary or precarious. There again, artists are often paid less than other parties.

We should also note that a certain number of artists go back and forth between the world of the arts, governed by the goals of excellence and public good, and that of the cultural industries that proceeds more from a logic dictated by the marketplace. The boundaries between the two streams have a tendency to blur, which benefits them both. Industry thus has access to an immense reservoir of talent, and artists who receive higher fees can continue to carry out their art in a world often unable to satisfy their economic needs. We observe this dynamic as it applies to actors working in both television and the theatre, for example.

Far too many artists, however, do not manage to work regularly. A socio-economic portrait published in 2004[28] revealed that 44.4 per cent of Quebec artists have incomes of less than $20,000 and share as little as 11.5 per cent of the total income. This type of observation is often cited by those who claim there are too many artists, too many companies, and too few barriers to enter into the artistic professions. But in my opinion, we must be careful not

to jump to such a wide-sweeping conclusion. It is not by placing additional limitations on these professions that we are going to change the situation.[29] The concepts of labour surplus or shortage are not viable in the case of artists. There will always be a relative shortage of creators of genius and actors who transcend standards established by their predecessors, and those who won't manage to make a name for themselves due to a combination of factors having little to do with their talent or technical competence.

Moreover, we must keep in mind that many professional artists derive income from other occupations not strictly artistic in nature, such as teaching. This explains why, for all Quebec artists, the average total income is $37,710, while that of all Quebec workers is $28,708 (a difference of $9,000).[30] If this observation seems incongruous at first glance, it is because statistical profiles on artists' incomes generally only take into account income derived from an artistic occupation.

But, globally, considering all the possible slight differences, the socio-economic condition of artists remains seriously out of sync in relation to the essential nature of their contribution to the cultural sector. The catching-up required will be the result of a change in the power relationships in the cultural industries, but will also necessitate an increase of targeted investments by all levels of government.

The future of the cultural sector is inconceivable without improvements in the remuneration and status of artistic creation and work. The portion devoted to direct arts funding should also be increased to ensure the future of cultural industries and the combination of activities in the economic sector. Given that federally, for example, we invest only five cents for each dollar spent in culture to fund the Canadà Council for the Arts, there is

plenty of food for thought. When we seek to explain the collapse of the North American automobile industry, we point the finger at the few resources invested in research and development, sources of innovation. It would be ironic if the cultural sector, which depends precisely on creation — that is, research, development, and innovation — and functions thanks to it, were exposed to the same risk.

To better contemplate the future, it is useful to seek to understand the evolution of this sector by placing it in a global and historical social context.

An Area of Activity Shaped by Public Policies

In Canada, even if we can trace back to the nineteenth-century federal, provincial, and municipal government decisions that had an impact on culture, notably in terms of archives, public libraries, and museology, public cultural policy was really only developed and set in motion as of the Second World War. This was also the case in Europe.

The first collective demand from Canadian artists for government support of creation took place in 1941. More than 150 artists gathered at Queen's University in Kingston, Ontario, to take stock of the situation of the arts in the country and create the Federation of Canadian Artists.[31] This historic meeting was followed in 1944 by the presentation of a report to a parliamentary committee responsible for examining measures for reconstructing the country after the war. *A Brief Concerning the Cultural Aspects of Canadian Reconstruction* was also called "The Artists' Brief." It constituted a plea in favour of federal support of the arts as an essential condition to true Canadian independence.

A few years later, in 1949, the Royal Commission on the National Development in Arts, Letters and Sciences in Canada (the Massey Commission)[32] began its work.

In Paris in 1948 the fifty-eight states that then made up the General Assembly of the UN adopted the Universal Declaration of Human Rights. Article 27 of this declaration states, "Everyone has the right freely to participate in the cultural life of the community, to enjoy the arts and to share in scientific advancement and its benefits." And everyone had the right "to the protection of the moral and material interests resulting from any scientific, literary or artistic production of which he is the author."

Having the right to cultural life and the rights of creators written out in full in a document destined to radically reform the world just after the Second World War — a war that had torn it apart, defaced it, and filled it with gloom — is of vital importance symbolically and historically. It expresses a refusal to bow down before what so many humanists consider to be the appalling proof of the collapse of culture and civilization. Indeed, after the inconceivable barbarity of the concentration camps, how could people be convinced culture had not failed miserably in its civilizing role? How to explain that the abuses of power, that torture and humiliation could have spread in educated and cultured Germany and Europe? Formulating Article 27 at that time in human history was tantamount to lighting a flame before darkness fell to prevent further attack.

The first time I personally focused on the importance of translating to daily life the sprit of this article in the Universal Declaration of the Rights of Man was in Belgium in 1994. I was accompanying the graduating class of the National Theatre School who were staging one of Wajdi Mouawad's first plays, *Voyage au*

bout de la nuit, based on the work by Louis-Ferdinand Céline. The show was performed at the Théâtre de Poche in Brussels. One evening, before a performance, Roland Mahauden, artistic director of the theatre, explained to me that he was involved with the Article 27 Association. The goal of this not-for-profit association is to sensitize people experiencing difficulties and to facilitate their access to culture in all forms. Article 27 Association gathers together cultural institutions, social support networks, and people in need. It makes it possible to distribute tickets to shows or exhibitions that are unsold, and above all to accompany people to the shows or exhibitions. As Roland Mahauden remarked to me, it is not enough to sit down at the theatre, even without paying, to appreciate a play. You have to be able to decode it. You have to understand theatrical conventions. Sometimes you also need to know the social or historical context in which the work was written. That is why he mobilized theatre and dance students to go see the shows with individuals experiencing difficulties. He invites them to play the role of cultural mediators. Ideally, a "before" and "after" should be in place to make the experience of an artistic show as meaningful as possible.

The Rush toward Art

In France, the concern for universal cultural rights as expressed in 1948 translated into a significant decision eleven years later. General de Gaulle, at the instigation of the writer André Malraux, created the Ministère des Affaires culturelles (the Ministry of Cultural Affairs). The new minister's intentions were clear. Thus, in one of his first appearances at the National Assembly, he declared "there is only one democratic culture that counts and this means something very simple. It means that in each region

of France, any sixteen-year-old, no matter how poor, can have meaningful engagement with his national heritage and with the glory of the spirit of humanity. It is untrue that this is impossible." Cultural decentralization and democratization were the order of the day.

That was the beginning of a new era that would have a profound impact in France, but also in Quebec and elsewhere in the world. Indeed, the 1960s were marked by the government's strong desire to professionalize the arts by pursuing objectives of excellence. Development of various artistic disciplines was encouraged. Creating major cultural establishments was promoted, especially in the urban centres. Public expenses targeted the growth of cultural activity by banking on artistic opportunities that came from professionals.

The awareness of the necessity of democratizing art then served as the basis for enlightened government interventionism. The forms of artistic expression perceived as elitist were to be opened to a larger public and wider audiences. Efforts were taken to facilitate access to "pre-electronic" forms of art, such as theatre, dance, opera, and concert music. Moreover, movies, TV, recorded music, and publishing were stimulated by granting subsidies and creating public companies and agencies dedicated to them. Here, as in many other countries, the goal was to encourage original and authentic artistic expression. Creating national cultural spaces was also a reaction to American cultural imperialism.

In Canada, within twenty years of the creation of the Royal Commission on the National Development in Arts, Letters and Sciences in Canada, cultural departments and ministries, arts councils, public broadcasters, libraries, archives, museums, training schools for various artistic disciplines, programs with scholarships for

creators, and subsidies for institutions were implemented. Sectoral policies were put in place to encourage diversified creative activity. A genuine national artistic and industrial infrastructure was created.

During this time, artists and creators organized themselves to plead their rights more insistently. They collectively claimed legal and economic recognition that until then were considered incidental or incompatible with an artist's life.

The optimism that characterized this era was intense. Speaking with the artists, thinkers, and important cultural figures who were pioneers, one realizes the extent and depth of their convictions and ideals. Everything had to be invented and at that time ideas did not travel with the speed of the Internet. Debates on art and society led to speeches and documents, the influence of which are still felt today. These debates were influenced by the great issues linked to democracy, peace, the cold war, and the issues of Canadian identity and aboriginal rights. If the pragmatic, sectoral, and regulatory approach prevailed federally, such was not the case in Quebec, where a more classical approach of cultural policy was adopted.

The Golden Age of Cultural Policy

In 1961, the Premier of Quebec, Jean Lesage, created the Ministère des Affaires culturelles, the ministry of cultural affairs. Largely inspired by the French model, and the thinking of André Malraux, Quebec's cultural policy allowed for strategies to be set out and tools to be created that would shape a cultural system in line with national, linguistic, identity-based, and civic concerns.

We can state without exaggerating that Quebec, from the start, clearly intended to establish a direct link between government support for a dynamic artistic and cultural life and developing a

set of shared social values. This connection between the cultural system, the very existence of the Quebec nation, and the promotion of the French fact is felt by a good part of the population. It is strongly expressed in moments of political, social, or humanitarian crisis. When it comes time to gather together and mobilize the people, Quebec inevitably calls upon its artists.

As for the federal government, it originally took its inspiration from the British model and, thus, institutionalized a healthy suspicion for political involvement in assistance to culture. The Canada Council for the Arts, the National Film Board, and the Canadian Broadcasting Corporation enjoyed legal independence that kept them at a distance from the immediate control of the government. This approach also allowed the federal government to play a significant role in cultural affairs without directly questioning the provinces' exclusive constitutional jurisdictions.

The Massey Commission considered that creating an organization to financially encourage the arts, letters, humanities, and social sciences was the surest means of ensuring cultural independence from the United States.[33] It also strongly emphasized that such an organization needed to be independent from any political influence and not conflict with the provinces' exclusive jurisdiction. The commission selected to model itself on the Arts Council of Great Britain, notably because it was autonomous and could make allowances for the constraints of the Confederation.[34]

The Arts Council of Great Britain was established in 1945 with the intent to separate the arts from politics, unlike what had occurred in Nazi Germany, where art was used as propaganda. Incidentally, the British government had openly recognized artists' desires to be masters of their creation and free from bureaucratic

involvement. This approach, also part of a long tradition of the British Broadcasting Corporation (BBC), created in 1923, was shielded from government control so as to ensure freedom of the press.

The Canada Council for the Arts was established in 1957 by an Act of Parliament. To establish the Council, Parliament allocated an endowment of $100 million, which came from the revenues of death duties of two industrialists, Sir James Dunn and Izaak Walton Killam. Half of the interest earned on this endowment was to provide grants to universities. With the other half of the endowment, it was hoped the Council would be financially independent from the government and could support the arts. This initial endowment was not enough, and the Canada Council for the Arts received its first annual budgetary allotment from Parliament in 1965.

Over the following years, the British model of the autonomous council for the arts was also adopted municipally and by most provinces in Canada with sometimes marked variants. While enjoying autonomy that limited direct political intervention, this system of arts funding integrated specialists and members of the artistic community to assess artists, artistic organizations, and institutions in order to award them financial assistance.

In Quebec, the complementary and sometimes contradictory forces between the two founding approaches of government-supported cultural development — the French one, based on Malraux, and the British one — often allowed leaders in the cultural community to enjoy the best of both worlds. They also encouraged progressive hybridization of cultural policies and instruments in Canada.

During the twenty years of implementing the great public

policies that set the foundations for the cultural sectors of most of today's developing countries, democratizing culture, expressing identities, and valuing creative freedom have been key objectives.

Obviously, powerful business and financial interests, essentially American, were also involved. The agreements of the Marshall plan to reconstruct Europe after the war[35] had opened the way to a global dissemination of American cultural productions, for example by requiring French cinemas to screen American films and imposing quotas for translation of American novels into French. Already at that time, ownership of the distribution channels largely determined the population's cultural consumption.

The Rise of Pragmatism

At the turn of the 1970s, several countries saw a widespread collapse of sectors of activity focused on extracting and transforming natural resources. When large industrial cities were thrown into a slump from which they had trouble recovering, culture's potential impact on job creation became appealing. Nothing more was needed to revive government interest in more proactive and aggressive sectoral cultural policies. People began to speak openly of cultural manpower and promoted cultural industries and the entertainment sector. There were changes in the humanist and universalist discourse on cultural policies. Artists and cultural associations lost influence in the decision-making. From then on, economists, lawyers, and urban planners began to have a say in the matter, and private producers and cultural entrepreneurs became very important players.

At the end of the decade, the President of the United States, Jimmy Carter, tried to openly shift the emphasis of the rare elements of internal cultural policy in his country by insisting

that the arts and culture serve primarily to express black identity in large cities torn apart by racial rioting.[36] From the moment Ronald Reagan came to power in 1981, he put an end to this approach by deregulation and mainly encouraging cultural industries and media concentration. He had announced his priorities during his inaugural speech declaring that "Government is not the solution to our problem; government is the problem."

In Canada, toward the end of the 1980s, echoes of American and European experiences in urban revitalization advanced, facilitated, or accelerated by culture caught the attention of public policy specialists. Civic decision-makers began to see that culture could successfully be brought to unhealthy and deserted downtown, urban areas disfigured or overpopulated, or areas plagued by violence and poverty. The public initiatives and investments necessary to leverage this socio-economic effect of culture in Canada nevertheless remained both modest and of secondary importance. Things did not change until civil society entered the picture, which I will explore later.

At the beginning of the 1990s, George H.W. Bush and the religious right that had brought him to power set themselves in opposition to the National Endowment for the Arts (NEA), the American counterpart to the Canada Council for the Arts. Saying that certain subsidized work was pornographic in nature and banking on the traditional distrust of the very principle of direct cultural funding from the government, they slashed the budget of the agency in 1996 to prolonged applause from the American Family Association, and redistributed part of its funds to individual states. The agency had to lay people off and a long defensive retreat was necessary due to the incessant war waged on it by the Republican majority in Congress, including during

the Clinton regime. The NEA became an even more marginal player in relation to the market forces. The share of direct public funding in the United States, all levels combined, today represents less than 7 per cent of revenue in the cultural sector. In 2005, the budget of the National Endowment for the Arts was proportionally ten times less than that of the Canada Council for the Arts. It was $125 million for the entire United States.

Cool Britannia

During the second half of the 1990s, the British began to document systematically the direct and indirect social impact of public spending in arts and culture. Taking correctional centres and hospitals, both in the boroughs and regions, as testing grounds, they sought to demonstrate that arts attendance, involvement in culture at an amateur level, and participation in cultural events promoted sociability, acceptance of various identities, psychological well-being, personal growth, and reduced interpersonal and multicultural tensions. It was observed that both in children and in adults, involvement in the arts improved their creativity and their ability to solve complex problems.

At the end of the 1990s, we saw concepts of inventive industries and creative cities appear in England: they were appropriated in 1997 by Tony Blair with the *Branding Cool Britannia*[37] approach.

Strategies for highlighting culture and artists were aimed at projecting a public image of sophistication, modernity, and a tendency to innovate. Cultural expenses were presented not so much as grants and subsidies, but as investments.

A fundamental shift appeared throughout Europe. Cultural development policies and projects were made to measure for cities and regions. Cultural, social, and urban site revitalization were

combined. Reorganizing the economy and tourism had massive public support and led to a more dynamic cultural life. This movement was supported by decentralization of the governments that entrusted regions and urban centres with new powers to which considerable funding envelopes were connected.

Cities Enter the Scene

In Canada, the federal government and several provincial governments slashed cultural expenses through the last decade of the twentieth century, but gradually cities started to take over. In fewer than ten years, municipal expenses connected to culture increased by 20 per cent.

At the turn of the current century, networks such as Les arts et la Ville and Creative City Network of Canada set out a discourse lauding decisive breakthroughs in terms of cultural policies and strategies, both regionally and municipally.

In the United States in 2002, Richard Florida published *The Rise of the Creative Class*, which became a bestseller worldwide almost instantaneously. In it, the university professor set out his concept of a "creative class" made up of qualified, mobile, and connected urbanites. In his essay packed with observations, anecdotes, and statistical tables, he claims that the economic future of cities lies in valuing talent, technology, and tolerance, the three *T*s. To classify cities, he suggests using a number of indexes — including the Bohemian Index, which establishes a correlation between the number of artists in a city and the development of the creative economy.

Admittedly, the "Ph.D. in running shoes" (this is how he was introduced to me when I worked with him in Montreal in

2004) has a keen sense of the system, an impressive mastery of marketing and media staging. He managed to create a genuine communicational whirl in North America and worldwide. This caught the attention of numerous politicians from all levels of government and also captured the imagination of the business community.

His caustic and well-documented critique of intolerance, refusal to change, and rejection of diversity embodied by the George W. Bush administration endeared him to artistic circles and progressive cultural leaders, who were seeking new arguments with which to question the political and private decision-makers. Even if Richard Florida's methodology and certain of his conclusions were virulently criticized by numerous academics[38] and he was criticized for his high-cost performances throughout the planet, the originality of his theories, his exceptional talent as a communicator, and his business sense allowed him to re-energize the discourse on the importance of cultural vitality.

A Beginning of the Century between Worry and Hope

By ratifying the North American Free Trade Agreement (NAFTA) in 1994, Canada subscribed to a dispensatory clause for cultural industries and to an exemption clause making it possible for partners to impose an economic sanction if another country's cultural policy measure harmed its own national economy. Thus, in 1997 the World Trade Organization (WTO) endorsed American claims to this effect, condemning Canada's decision to tax the income of magazines with Canadian content not reaching the 80 per cent threshold.

This decision of the WTO immediately spread worry throughout the cultural sector in Canada and elsewhere in the world.

It sparked general mobilization for a pitched battle for cultural diversity. The governments of Quebec and Canada played a dominant role. Admittedly, they were spurred on by numerous leaders in the cultural sector, both from its industrial component and from the arts and letters.[39]

Mobilization of the political community in France and in several countries was very strong, particularly in respect of the film and sound recording industries. The issue was perceived as fundamental to the interests of France, as national filmmaking was directly threatened. As the international jurist Monique Chemillier-Gendreau said, "The fundamental basis of the political community is that of public good. Therefore, protecting the public good is the responsibility of the political community. The WTO is trying to reduce it to an exchange: I produce, you buy. But culture is not that simple: we meet up, interact over the creation, and it sets our sensibilities, imaginations, intelligence, and receptiveness in motion. For culture is nothing other than the infinitely extendable 'we' of human beings. And today that is in danger and requires our mobilization."[40]

The alliance between civil society and the governments of several countries allowed for the implementation of a worldwide campaign that led to the adoption of the Convention on the Protection and Promotion of the Diversity of Cultural Expressions by UNESCO in 2005. In accordance with this convention, national governments could now maintain their cultural policies and take measures to protect the cultural and artistic expressions of their population. When the vote was held at UNESCO's 33rd General Conference, 148 countries supported the resolutions, four abstained, and two opposed it — Israel and the United States.

That same year, the Quebec National Assembly unanimously adopted a motion to sanction the Convention, a world first. Shortly after, Canada became the first country to ratify the Convention, which today enjoys the ratification of more than eighty countries. The campaign for ratification continues.

If the twentieth century saw the Americanization of world culture and more or less successful national attempts to contain it, this is unlikely the case for the century now begun. Diversity and authenticity of cultural expression are everywhere. The weakening of the United States' power of influence following an internal financial crisis contaminating the world economy and President Barack Obama's arrival to power are factors that may play a positive role in the short and medium term.

In May 2009, at a social event at the Metropolitan Opera, Michelle Obama declared that arts are not a luxury you give yourself when you have time and money; they are essential to the complete emancipation of every American citizen. She specified that she and the president were convinced that improving access to the arts for all children, notably through the education system, is a necessity. There was hope, especially when she emphasized that all young Americans who want to engage an artistic practice as professionals or amateurs must have this opportunity. She was not referring to the entertainment industry; she specifically named poetry, dance, visual arts, and music. This marked a significant change not only in government, but a change in the tone and priorities of a country that has dominated the globe economically and culturally since the end of the First World War.

Due to the devastation of the economic and financial crisis that closed the first decade of this century, we can see a powerful

international movement emerging, one that encourages a return to public policies and regulations. Everywhere, including the United States, people claim they want to control market forces. The doctrine of laissez-faire capitalism and its multiple neo-liberal variants do not wield the same political power as they did ten years ago.

The time is no doubt ripe to bring back to the forefront the principles of cultural policy that have been abandoned. All that is left from the extravagant promises of a global economy is unlimited and unchecked competition that were supposed to have driven us to newer and newer heights. We were obviously wrong.

The Dangers of Losing Points of Reference

The cultural sector as we know it has been shaped by several factors and trends for about sixty years. After the assertion of the major principles of humanism, we saw a kind of economic and social utilitarianism emerge and, more recently, the diversity of cultural expression was promoted. Each of these movements added an additional layer of discourse that today are part of the environment in which the cultural community in Canada is evolving.

Here we are seeing, in fewer than ten years, an unprecedented multiplication of the programs and initiatives strong in cultural content not based on the long-standing principles of cultural policy and not under the governance of existing ministries, departments or cultural entities. The ministries that manage portfolios dealing with finance, education, tourism, housing, social welfare, and even justice and transportation are more interested in the impact of culture and are releasing funds to facilitate it. Regional and municipal administrations do the same and try to derive benefits

for their citizens. The cultural public servants see these developments as favourable, noting that they cross departmental and ministerial boundaries, and fulfill the government's priorities.

The number of authorities and structures with budgets and capacities for cultural initiatives increases every year. The motivations are many and sometimes even contradict one another.

Various political and structural phenomena foster this deconstruction of the centralized and vertical cultural approach. First, governments can no longer ignore the rise of regional demands and the assertion of power of the large cities. As for civil society, increasingly diversified following the migratory movement, it refuses to play the passive role in which it had been confined when it came to adjusting the structure of cultural systems. In many respects, the very notion of a cultural policy is weakened in a sea of intentions, more or less realistic and reconcilable in the long-term.

Stakeholders in the cultural sector must thus learn to come to terms with variable logic and negotiate with a multitude of new partners.

Long an orphan, then placed in shared custody between the federal government and the provinces (especially in Quebec), the cultural community now has many adoptive parents, filled with good intentions, but who often have not yet had time to develop the parental skills required. For now, intentions and goodwill are what count. People speak of progress and of opportunities. Silos no longer stand apart and alone. Bridges between the strongholds are increasing. Ministers of culture are no longer condemned to preach eternally in the wilderness and share podiums and press conferences with industry and tourism.

Stakeholders in the Canadian cultural community have developed genuine expertise in dealing with the two major approaches of cultural policy, with at least two governments, many sources of funding, coexistence of ministries and arts councils, funding sources, and numerous regulating authorities, municipal cultural services, and sometimes with city arts councils. The cultural system was already very complex, but now it is expanding, branching out, and splitting up.

It may not be any consolation, but we should note that we are not the world champions when it comes to proliferation of local structures and cultural initiatives. France is legendary in this area. I note in my exchanges with colleagues of several countries that the phenomenon is quite widespread; many are delighted with this irrefutable fact, arguing that it opens new possibilities and objectively protects freedom of creation and expression. Now no one can actually impose his or her viewpoint as the sources of funding and related criteria are more diverse. Moreover, the subsidized cultural system, which had a tendency to close in on itself to protect the few resources it had, is enjoying a second wind. Culturally diverse and emerging artists can access it in new ways; things are freeing up for emerging artists who, understandably, are chomping at the bit.

The players in the cultural sector can and must seize these new opportunities. But the rapid loss of centrality and the sudden levelling of the already vague pyramid of cultural policy, defined by canons of democratization and creators' rights, leads also to risks and dangers. In wanting to make culture much more profitable on the economic and social fronts, even with the best intentions in the world, we could lose sight of the fact that artistic creation is an essential and irreplaceable engine of cultural develop-

ment, requiring staunch protection and enlightened constant financial support, independent from market forces.

Moreover, we should note that, at both the national and international levels, reconfiguring cultural policy is especially hastened by technological changes and pressure from financial groups that control the distribution network of cultural content. Yet artists, creators, and cultural workers continue to be grouped together in an excessive number of associations, unions, structures, and committees[41] that divides their voices, while the individuals and groups that control the cultural industry are less numerous and increasingly better organized. Creators and artists run the risk of being neglected once again.

We need a strong and viable cultural sector, but its future is too important for everything to be settled by negotiations among individuals and entities who are often in a situation of inequality by opaque dealings with governments.

I am convinced we need to do all we can to prevent a complete loss of point of reference in terms of cultural development, but without discouraging new initiatives. We must sort through the various goals and re-establish a hierarchy of values that respects the needs of creators and the interests of citizens.

We must go out in public and urge citizens to take an interest in culture as a dimension of their individual lives, and, above all, as an indispensable dimension of their collective existence.

CULTURE AS AN ESSENTIAL DIMENSION OF THE HUMAN EXPERIENCE

Culture constitutes an essential dimension of our humanity in its individual and social expression. It is the key to three fundamental apprenticeships: learning to know, learning to be, and learning to live together.

Emerging from the Sectoral Framework

As I attempted to demonstrate in part one of this book, culture may be understood as a sector of activity with defined lines. Over the course of the last sixty years, the sector organized itself and operated in ways specific to it. Its true engine is artistic creation, whether current or past. This sector possesses and manages specialized physical and virtual infrastructures. Its economic weight and impact are measurable, even though much still must be done for the measure to be exact and widely accepted. It reacts and adapts itself to market pressure, consumers' preferences,

technological advances, and demographic changes. It is an area of activity stimulated, supported, or negatively affected by a wide array of laws, regulations, and political decisions stemming from logic that is more or less compatible.

But make no mistake: the arts and culture are not and should not be the prerogative of the cultural sector, however important and dynamic it may be. First and foremost they are fundamental attributes of human beings. Culture constitutes a dimension of life that precedes and surpasses sectoral and economic concerns. By ignoring this consideration, rejecting it or abandoning it out of annoyance to anthropologists or philosophers, we are *de facto* reducing the discussion of culture to essentially financial and commercial concerns. Moreover, in so doing we are mortgaging development of the cultural sector itself by isolating it from the socio-political dynamics that shape it and which it can influence.

Broadening the Perspective

Legitimately, individuals, institutions, associations, unions, structures, and businesses belonging to the cultural sector seek to extricate themselves from difficult situations. But I stress that we must resist the temptation to assimilate the debate on culture to that of the cultural sector's future or any of its components. Succumbing to that would be one of the best ways to widen the gap further between the cultural community and the general population.

This gap exists indeed, even if it is unpleasant to admit. It is the result of more than a century and a half of survival of elitist attitudes. At its most blunt, elitism considers access to arts and high culture as a factor of social discrimination, a way to affirm the superiority of some people in relation to others.

Elitism in all forms, and despite its most subtle disguises, discourages cultural participation of the majority. The gap it widens could easily become an abyss if nothing were done. But the gap cannot be filled just by shovelling in loads of good intentions. The task is more complex and arduous, requiring application, patience, and perseverance. Fortunately, we can address it with recourse to the immense intrinsic power of transformation, reinvention, regeneration, elevation, and emancipation shared by the arts and culture. This observation has led so many artists and intellectuals that came before us to believe that culture, like education, is not only a factor that forms and defines every human being, but also one of civilization and progress.

Culture as a Lifeline

Our relationship to culture starts at an early age, as soon as we are aware of others. It becomes crucial and decisive at adolescence, as that is when the urgent need to understand ourselves begins. We raise our antenna, and often show signs of indifference, rejection, or rebellion to conceal sensitivity and malleability that make us easily influenced. We seek to drink in sounds, images, and words to satisfy a burning desire to learn about life and its possibilities. We shape our personality and our own identity in relation to the world. Encountering works created by artists is personal, intimate, and sometimes symbiotic; it has the power to influence the person we are to become. Tell me who you chose to listen to, see, and read during your youth and I can begin to understand who you are.

Our cultural choices are sometimes instinctive and spontaneous, but often are influenced by family, friends, or certain teachers.

Pressure exerted by multinational entertainment companies, advertising, the Internet, television, brand names, trends, and fashions is also constant, if not tyrannical. Billions of dollars are spent each year on campaigns and advertising strategies to reach teenagers and young adults. Culture serves as bait for consuming a vast number of products and services, not to mention that the cultural products themselves are for sale and sometimes expensive.

We live in a world where it is almost impossible not to be enticed by cultural products of all kinds and shapes and of varied quality. The availability of products and cultural experiences has grown exponentially, creating a thunderous racket, especially in the large urban centres of wealthy countries. This, again, is a recent phenomenon in the history of humanity.

But this variety of offerings does not mean that issues regarding access to arts and culture are settled. The intimate and influential encounter with a work of art does not depend upon the facility and speed of the communication and transaction methods. Culture is not a vacuum-packed meal or a bottled beverage meant to please everyone, ordered over the Internet and to be swallowed in one gulp for immediate satisfaction.

In the best case scenario, the works we choose to interact with calm or stimulate us, and encourage us to reflect or to distance ourselves from oppressive reality. They reflect and accentuate emotions; they challenge or enlighten us. We are unique, complex beings grappling with mysteries, questions, and situations that disturb us or are often beyond us. We do not live our lives according to a blueprint handed down by the gods. We constantly seek to see ourselves in works of art, to find artistic explanations for our daily or larger problems. We also seek new pathways to beauty, pleasure, and happiness.

We need to be able to make our choices for participation in the arts, based on artistic presentations that are meaningful and will have a lasting impact. And while we can interpret, transform, or complete them by placing ourselves into them, their meanings initially stems from the works themselves. Real and continued access to a variety of works, proposals, and significant cultural experiences beginning in adolescence and lasting through life is essential. We cannot choose what is inaccessible.

The artistic creations that influence us will differ from each other. They do so because they are the products of varied and contrasted times, cultures, and societies, and belong to various artistic disciplines and forms of expression with codes of their own. They are associated with ways of production and dissemination ranging from handmade artisan crafts to the greatest technological feats imaginable. No matter the differences between the artistic creations with which we engage, we encounter them at precise moments in our lives, in a defined present, which shapes our perceptions of them.

I have always observed how engagement with the arts differs among my peers, both when I was an adolescent and now with my colleagues. When I was a teenager I developed an insatiable appetite for rock music, surrealist poetry and painting, absurd humour, independent films — from France and Quebec, mostly — for socially committed songwriters and Léo Ferré and for poetic writing, among other things. This was before the time of the Internet and, unfortunately, my choices were never too abundant, yet I did not become bored with these limitations. I had to go to the libraries, bookstores, museums, movie houses, and theatres to satisfy my hunger. My family lived in Montreal's Villeray district. Despite our modest economic conditions — I was the eldest of

eight children and my father was a lab technician and later a Cégep teacher — I had access to the abundant cultural offerings of a large city.

Encountering cultural works and worlds in youth is an intense experience that creates a lasting impression. These works become personal landmarks. I only have to reread Gaston Miron's poems in his collection *L'Homme rapaillé* to experience, as I did at age twenty, the feelings of alienation, amorous rebellion, and obstinate hope they created in me. Repeatedly reading these poems helped shape my sense of myself, my identity. Seeing again the black and white images of Gille Carle's film, *La vie heureuse de Léopold Z*, I feel the weight of the stories of urban snowstorms in my personal universe shaped by the City of Montreal.

During this formative period in my life, no hierarchy of cultural works and habits took hold. Eclecticism suited me better. Even today, if I want to retreat into myself, I tend to select the protest songs of The Clash or Jimi Hendrix's electric baroque in my iPod. I abandon myself spontaneously to the strident sound of amplified guitars and heavy rhythm of the bass and percussions, rather than to the contemplative effects of classical music. Should I have been more exposed to classical music in my youth? Is it a sign of my relative lack of culture? Perhaps. But rock in all its forms is also culture, even though it is subject to the commercial objectives of big business. Like hip hop, rock plays an essential role for hundreds of millions of young people who connect to the world through its works and artists. As in all cultural movements, there can be magnificence or vulgarity, virtuosity, or the routine and predictable, and originality seeks to shine through despite the formats and conventions imposed by the distributors of culture.

However, my liking for rock music does not prevent me from being profoundly moved and transported listening to the soprano Emma Kirkby and counter-tenor Daniel Taylor interpret Pergolesi's *Stabat Mater*. Attending specific cultural events on a regular basis should not exclude others by definition. This requires the individual to remain open to many forms of artistic and cultural expression. I have come to realize this even more in the last twenty-five years, while immersed in the world of theatre, a world I did not attach much importance to before becoming an active and engaged citizen of it after I was hired by the National Theatre School.

The Freedom, Possibility and Responsibility to Choose

Unless a person is a professional artist, a meticulous collector, or a specialist, our individual relationship to the arts and culture is not likely to be systematic. It is rather a function of life circumstances. It is fragmented and arbitrary.

Like many people, I have gleaned over the years aspects of several cultural worlds that I needed in order to grow and live. Sometimes they lie dormant in my memory, or are there randomly. I would not want anyone to put them in a specific or systematic order, carefully sorting out what belongs to high culture from what is a part of popular or commercial culture. I would not want someone to try to assess the depths of emotion I feel listening to Lucinda Williams sing "Fancy Funeral" or Arcade Fire play the first bars of "Crown of Love." Nor would I want someone to measure the profound disturbance I experience upon hearing Wajdi Mouawad's volley of words or seeing Dave Saint-Pierre's choreographed chaos. I want to have the right to stop and smile without self-consciousness when I see Joe Fafard's bronzed cows

grazing on the lawns of Toronto's financial district. I do not want to be made self-conscious of how caught up I become when I lose myself in a painting by François Vincent or to become aware of the exact extent of my serenity when Leonard Cohen's deep-pitched voice lulls me as he sings his "Hallelujah."

I want to believe that artistic works and creations that don't yet exist or that I've not yet discovered will become significant to me in my journey upon this earth. The arts and culture hold promises of other visions. They renew the invitation to remain open to experience the world.

A Universal Culture?

By reflecting on the continuous shaping of my own personal relationship to culture, I understand the historical confrontation of two large schools of thought on this subject the local, or relativist, and the universal, or universalist. My thoughts on this dynamic are not conclusive, even if my upbringing makes me lean more toward the latter.

The universal approach places cultural expressions on a continuous line that starts with savagery and continues until today, the most advanced state of civilization. This perspective leads us to compare and appreciate cultures in relation to one another. We also seek to establish a hierarchy that values the most modern culture, the one that makes way for reason, rights, and values that are universal. By extension, we may classify works based on their degree of universality. Certain theorists and politicians, in France notably, have taken this reasoning very far, as evidenced by their speeches at the beginning of the 1990s on the French cultural exception from the World Trade Organization rulings. But, admittedly, it is by starting out from this position

that France became involved in the battle that ended with the adoption of the Convention on not only protecting but promoting diversity of cultural expression.

That said, the universal approach lays itself open to serious and significant criticism. Universalism can feed a form of ethnocentrism by claiming that the artistic creations of western cultures, specifically European cultures, should be considered as the universal cultural standard or reference point. Throughout the twentieth century, the universalist doctrine facilitated a clever camouflage of the preceding century's elitist beliefs. Thus the richest and most educated people continued to participate in cultural customs that helped to distinguish them from the mass of their contemporaries. Obviously, this contributed to instituting mistrust or indifference of a good part of the population in terms of cultural activities, seemingly reserved for a minority that knew and understood the codes buried within them and could, thus, access them.

French theatre director Antoine Vitez summed up the importance of doing away with the weighty heritage of a culture for the elite by inventing a slogan to shock people: "Elitist culture for all." To my mind, this slogan is valid still and well worth defending.

It's Not All the Same

As opposed to universalist discourse, tenants of relativism immediately reject comparisons among cultures and argue for protecting each specific culture in its entirety. A relativist perspective values popular culture as opposed to a culture reserved for the ruling classes. This argument becomes obviously very useful in promoting large-scale commercialization and consumption of cultural products on the pretext of cultural democracy.

Relativism also opens wide the door to appalling behaviour such as populism, demagogy, and simplistic patriotism.

The confrontation between universalism and relativism no longer dominates the current debate on culture as it once did. Admittedly, the dogmatic excesses of both these perspectives still profoundly influence our judgments, decisions, and attitudes.

In the artistic world, we are rather quick on the trigger when we perceive the possibility of confusion between what stems from popular culture and what comes from higher culture. This over-cautiousness no doubt arises from the fact that globalized commercial culture asserts itself as being the popular culture, while a culture of signification, which values art, is pushed to the sidelines, thanks to commercialization and consumption. What used to be the culture of the elite has thus become a marginalized culture. This movement can only be slowed if we count on cultural democratization instead of expressing our distaste at popular culture, as if all that is popular is, by definition, devoid of artistic value.

In these discussions, we must show discernment instead of falling into the trap of merely labelling that which we do not like. This is what I observed recently when a skirmish without repercussions occurred through a series of emails. In an opinion piece published in *Le Devoir*, I stated that more than ever we needed to hear the words of our artists beyond and in spite of the racket of the economic crisis that was proving to be a profound crisis in values. In the same sentence I placed the names of well-known poets, authors, choreographers, and directors. But I had also included in my short list the name of an author-composer and popular singer whose writing and music I found strong and original. That was all it took for two artists supported by the

Canada Council for the Arts to send me emails criticizing me for mixing genres by associating a commercially successful singer with artistic creators recognized by their peers and thus legitimately subsidized. They stopped short of accusing me of showing cultural relativism. I can only imagine the reaction had I also included the name of a humorist able to make us think with intelligence and talent.

Yet it is completely false to claim that an artist is not an artist if he or she does not evolve in the not-for-profit world supported by the arts councils.

An individual seeking to connect with a work is not interested in a classification of artists based on a position in the list of grants recipients in the subsidized cultural system. The relationship between the public and an artist is often passionate. Of course, and very fortunately, there are connoisseurs and an informed public for every form of art. But the artists and works they value do not belong to them exclusively. The notion of exclusivity brings nothing to the art. Any effort to exclude or discredit those who are not connoisseurs places the legitimacy of an art form or its practitioners in peril.

By now it is clear to the reader that I refuse to join, eyes closed, the camp of those who decry, with spectacular drama and a tinge of condescension, what they qualify as prevailing cultural relativism. According to them, this triumph of relativism has replaced the desired and correct hierarchy of works. It has shaken up the ideal pyramid of good taste and knowledge and almost irreparably divided the bases of a perfect construction to which only a few privileged people could be initiated in the classical education of times past or through writing a doctoral dissertation.

I am wary of the obsession to classify artistic works and cultural

productions with stickers on which have been carefully written words such as *classic, contemporary, current, avant-garde, marginal, ethnic, traditional, emerging, popular, urban,* or *commercial.* The arts and the true artists do not need these classifications, especially when it is only a pretext to assert the erudition of those who make them.

Any person who sincerely gives his or her contemporaries the best of what he or she has to offer deserves respect. Obviously, all works are not equal. All artists are not excellent. We need to be able to distinguish what is original, genuine, and mastered from what is banal, routine, and poorly rendered. This must be done rigorously before allocating a grant or an award of excellence. Comparisons and distinctions based on artistically and socially agreed-upon criteria are essential for the advancement of each artistic discipline and the protection of the legitimacy of a cultural system largely financed by public money. But it always involves judging the object and not the subject. A poem may contain stereotypes, but the poet may be sincere, and those who listen to him or her may be moved. This is nothing to criticize. Disdain does not serve art nor does it foster excellence.

I refuse to decry the rise of cultural relativism by citing the canon of the classical curriculum, and I also refuse to be taken in by consensus-seeking words that some programmers use to justify a lack of imagination. I certainly do not want to be complacent regarding conglomerates preparing to release a continuous flood of cultural products of mediocre quality thanks to the powerful technological pipeline embodied by the new multiplatform media. It is disingenuous to claim to bring people together around culture when in fact these corporations seek to have us consume ready-made products that are to culture what empty calories are to healthy eating.

Supply, Demand, and Cultural Participation

We live in an era with an abundance of cultural products. The illusion of access to culture for everyone has never been so strong, comforting, and commercially profitable.

Supply outrageously dominates the current cultural equation. But what happens to demand? And what cultural demand should we address? What do we need to do for this demand to express true cultural needs and not be the result of a systematic incentive to consume? How to encourage the discovery and expression of cultural aspirations and needs of each human being? How to encourage cultural participation that places citizens in contact with the arts? It seems to me that we should ask these questions and try to reply to them even more carefully at a time when the promises of technology may result in reducing cultural participation to a frenetic consumption of the latest trends.

Knowing my interest in the subject, a few years ago an American colleague sent me a study I found particularly enlightening because it addressed the issue of cultural participation from the participant's viewpoint.

Conducted by the Connecticut Commission on Tourism and Culture, with the support of the Wallace Foundation, the report, published in 2004, is called *The Values Study*.[42] Conclusions drawn from the minutely detailed analysis of in-depth interviews carried out with one hundred citizens of the state are presented. These people were selected by about twenty cultural organizations (five per institution), spread across Connecticut. Subjects selected for the interviews were required to have varying levels of cultural participation, from frequent attendance at activities offered by these organizations to non-participation. The study

tried to reflect diversity in terms of income, age, and ethnic origins.

Analyzing the responses and comments expressed in the interviews, the study's authors were able divide participation in arts and culture into categories. They defined the characteristics of five forms of cultural participation based on the degree of creative control exerted by the individual involved: 1) inventive mode, 2) interpretive mode, 3) curatorial mode, 4) observational mode, 5) ambient.

The inventive mode actively seeks and engages the person's mind and body in an activity involving artistic creation, regardless of his or her talent and real mastery of the discipline undertaken. This mode applies to amateurs who compose, write, improvise, choreograph, draw, sculpt, etc.

The second mode of participation, interpretative, is based on activities interpreting pre-existing works that engage the individual, alone or in a group. This is the one undertaken by people who participate in choral singing, theatre, dance, who play a musical instrument, etc.

The curatorial is a widespread mode of cultural participation. Here the activity involves selecting and acquiring books, paintings, *objets d'art*, music — including downloading for a person's use and personal pleasure.

Observational mode is the participatory mode that consists of selecting a play, concert, exposition or festival based on expectations and preferences. It also includes watching movies at home or listening to cultural programs on radio or TV.

The fifth mode of participation is appreciation of the ambient milieu. The individual makes no selection other than being more or less open and attentive to available works of art or cultural

offerings. This participatory mode is often neglected, yet is extremely important and valued by many people sensitive to public art, design, architecture, or the presence of musicians in the subway.

This study, which distinguished and assessed various modes of participation, allows us to understand better the motivations and attitudes of citizens in relation to a wide array of cultural offerings.

The interviews allowed for the participants to draw up a list of values and attributes they associated with their engagement with the arts. Thus, beyond the aesthetic experience they said they were seeking, first and foremost, they mentioned cognitive values, as the brain is stimulated and the imagination engaged. They also spoke of emotions that are aroused or experienced. Individuals who devoted themselves to dance, theatre, or other performing arts noted the significant impact of the connection between mind and body. Several brought up socio-cultural values such as understanding and gaining an appreciation of ethnic or generational differences. Some insisted on political values, because art allowed them to express opinions or comment on social situations. Spiritual values were also associated with art — many people felt transformed or renewed as they came into contact with it. Most participants in the study also mentioned the notions of identity, self-esteem, pride, and dignity to express what they derived from their participation in cultural activities.

The authors of this report also made some useful observations to try to encourage more diversified, satisfying, and enriching cultural participation for the majority.

I have selected three that I will describe briefly.

First: involvement in activities of creation and interpretation

allows people to appreciate all values and attributes listed above the most intensely. The study stresses that this experience depends little on the level of knowledge, technical skill, or mastery of the form of art practised.

The second observation is that the great majority of the study's participants spoke of the importance of education and familiarization with the arts during childhood. This is a recurring theme throughout the world. What are we waiting for to take action in this area?

Finally, several of the interviewed made it clear that a direct connection with professional artists, thanks to family members, neighbours, or others, could awaken a latent interest and inspire more active cultural participation.

But what struck me as I read the report was that almost everyone who had engaged in artistic creation insisted that in no way did they consider themselves to be artists. Even the most talented and creative individuals felt the need to make negative comments concerning their own abilities, which demonstrates how important it is to value artistic creation for itself, whether or not it is done by professionals.

Even then we don't avoid it: we note that an intimidating distance has taken root between the general population and professional artists, including among people who appreciate arts to the point that they take part in them as amateurs. This distance is sometimes maintained by the artist themselves, as I noted at the occasion of the seventh *Journées de la culture* in Quebec in 2003. Certain professional artists were offended by the advertising campaign created from the slogan, "Bring out the artist in you." "You are implying that anyone can be an artist," they criticized. Once again, a legitimate issue, such as the recognition

of professional artists, was contrasted with an attempt to encourage cultural participation. Yet everyone cannot become a professional artist, nor do they wish to. No fear. But as we know that artistic creation, imperfect as it may be, is enriching for every person who engages in it, why would we neglect to promote it?

The Important Thing is to Participate

"Tell me, and I will forget. Show me, and I may remember. Involve me, and I will understand." This saying, attributed to Confucius, illustrates my point.

We notice an increase in the phenomenon of "non-audiences," particularly in big cities. The "non-audience" represents the portion of the population that is completely indifferent to or not aware of the cultural offerings made possible by government subsidies in an effort to democratize the arts. Many factors contribute to this state of affairs: poverty, illiteracy, incomplete education, insufficient mastery of the language, family situation, lack of time, mobility issues, etc. There are serious economic and social obstacles to overcome exclusion from cultural events.

The mainsprings of cultural participation are many. Attendance at arts events can take different forms and their intensity may vary. But one thing is certain: all participation must be encouraged, facilitated, supported, and valued socially. This involves education, time, practice, reinforcement, and an adaptation to the needs, affinities, circumstances, and rhythms of each person.

Family, school, extracurricular activities, and organized recreation should play a key role in promoting such participation. We must continue the fight for this to happen; however, like the health sector, which can no longer simply care for people but

must also do preventive work, the cultural community must defend and promote democratization and cultural participation.

The resources cultural organizations possess to lead this democratic crusade are marginal, almost pathetic. And nothing indicates that the situation will change radically in the short or medium term, even though the concept of cultural democratization is beginning to take hold, as in Quebec. Public investments and private donations and sponsorships promote cultural productions almost exclusively. But the tide is turning. Promising projects are emerging and are often showcased thanks to an annual event mentioned earlier in this book: the *Journées de la culture*, a project currently in the making in the other provinces in Canada under the banner of "Culture Days."

The Journées de la culture in Quebec: An Innovative Pact

For the last fourteen years, organizing and setting in motion the *Journées de la culture* throughout Quebec allowed us to attract attention to the issue of cultural participation. By taking the debate around culture, to some extent, out of universities and government agencies, and bringing the issue back to the street, we encouraged lively discussion and debate on the democratization of culture. Over the years, organizing these *Journées* mobilized thousands of artists, craftspeople, facilitators, art students, and cultural workers in a symbolic, collective, and prolonged action, fostering access to artistic presentations, productions, and cultural life. We counted on simple, friendly, educational activities offered free of charge during one fall weekend throughout Quebec. By organizing communication campaigns to encourage members of the public to meet directly (without intermediaries) with the artists, companies, and institutions, we perfected a system to create

cultural participation. We also managed to include artists from all disciplines and organizations of all sizes. We mitigated tensions between the large and small cities and between the urban areas and the rural regions in order to carry out a concerted operation; the whole was much greater than the sum of its parts. The credit first goes to Culture pour tous, and to the dedication of its team, under the enlightened and tenacious direction of its founder and CEO, Louise Sicuro.

This success is also due to a new kind of pact concluded in 1996 between the cultural community, politicians, and leaders of some private companies already actively involved in supporting the arts and culture. Thanks to this pact, supported from the start by the Government of Quebec, we shared intelligence, expertise, and resources for a cause and movement that would give meaning and a new breadth to what we each do all year. Since then, we have renewed our ties to the democratic ideal of art for all by forcing ourselves to review and revise the pact at each year's new cultural season.

These *Journées* are a collective antidote to the selective amnesia that relegates to oblivion the issue of access of the greatest number to culture. As a bonus, the process is festive. It contains no secret ingredient and its effects increase with exposure to culture. If the program, however, is interrupted, stalled, or stopped, all progress may be reversed.

Today, in addition to diversifying its activities in Quebec, the organization Culture pour tous counsels artistic organizations and government agencies wishing to use the *Journées de la culture* as their inspiration in launching similar movements in the other provinces, as is happening now with "Culture Days."

The Ends Justify the Means

The *Journées de la culture* constitute an original, concerted pattern of action that fosters cultural democratization. They are also an evolving model, placing a wide variety of cultural, political, and financial stakeholders in direct contact with each other and the public. Tested by time, it has lasted and continued to grow in its specific geographical and cultural space; this model has a promising future. It is a local and specific response to a global issue that we might never have addressed.

We must also acknowledge the many initiatives of democratization stemming from various cultural institutions.

For a long time, public libraries have been at the heart of the democratizing of knowledge, the arts, and culture. They are still the foundation of municipal cultural involvement and continue to weigh heavily in the budget of all provincial ministries of culture and municipal budgets. The good news is they are also the cultural institutions most attended by the population in rural and semi-rural regions as well as in large, cosmopolitan cities. Very often they are the entryway for children and immigrants into the cultural world. Over the decades, they have become something far more than repositories from which books are borrowed. Thanks to standardized programs, but especially thanks to the vision of enlightened and committed librarians, certain public libraries have become key places for cultural engagement. They host writers, poets, and offer various programs to make people more aware of artistic practice. They collaborate with schools and community and artistic organizations. I have been advocating for several years to bring together librarians, artists, and other cultural stakeholders, because each of these groups has tools and knowledge that can help promote cultural participation.[43]

The synergy between local libraries and the new large libraries and media centres that have been built for approximately the last twenty years in the metropolises of the world has given a second wind to strategies focused on attendance at these crossroads of culture and knowledge. In Quebec, we have been fortunate to see in recent years the Grande Bibliothèque du Québec (GBQ) emerge under the enlightened and determined leadership of Lise Bissonnette, the former publisher of the newspaper *Le Devoir*, who is very aware of cultural democratization. She gave the GBQ an orientation that was exemplary in every respect. Montrealers of all social and ethno-cultural origins flock to the premises, confirming this. I observed a similar reality in the large public libraries of Vancouver and Toronto, where the diversity of users is a much truer reflection of those cities' demographics than can be noted at premieres in theatres or in concert auditoriums.

But we must recognize that museums and presenters of performing arts are also putting more into designing catalogues, programs, and signage that inform the public of the intentions of artists and the significance of the works they are presenting. People are organizing discussions involving audiences before or after their shows to encourage communication among all the participants: the audience, the artists, and the designers. Museums offer educational programs in which they loan their offerings in order to meet a larger public.

Even specialists in contemporary arts seek to communicate in lively, accessible language far removed from the specialized, opaque jargon that prevailed scarcely a few years ago. People are referring more to concepts such as *open work*, which conveys the idea that a work is not complete or completed as long as the public has not yet encountered it. In a catalogue for the summer

exhibition presented in 2009 at the Espace Shawinigan by the National Gallery of Canada, curator Josée Drouin-Brisebois comments on the works selected, emphasizing that "these sculptures and installations unquestionably involve the participant, who becomes just as important, if not more so, than the author, the artist." She declares that art includes the viewer and that sometimes it depends on him or her.

Set designing of exhibitions, interactivity, and imaginative and playful contextualizing of works are other means used to increase cultural participation. On the National Ballet of Canada's website, viewers can listen to Karen Kain explain the approach of the choreographers that she has invited. The use of the Internet also allows for creating virtual communities focused on the activities of artistic companies. Live broadcasting of the Metropolitan Opera's productions in movie theatres and the free outdoor presentations of opera house productions in Montreal and Toronto are also ways to popularize the art form. (Incidentally, the use of surtitles in opera is a good example of a Canadian invention[44] that has spread throughout the world, although initially it had caused some purists to pout. Subtitles are now used by Robert Lepage and others who want to have the theatrical text travel into other languages. The Théâtre Français de Toronto has used surtitles recently, eager to welcome English-speaking spectators to its productions.)

We must also applaud efforts made to offer spectators and visitors a more satisfying, engaging, and complete cultural experience in line with their daily needs. Opening restaurants and bars in theatres and museums, allowing people to meet before and after the event, organizing supervised daycare for children and training staff to welcome rather than supervise visitors

are valuable strategies for integrating the arts and culture with everyday life.

Cultural institutions are increasingly aware of the importance of the issue of democratization. They realize their future depends upon it. Even when they start with the obvious ambitions of marketing, their attempts to build bridges with new audiences help to promote cultural participation of a greater number of people. But cultural institutions and actors cannot meet this immense challenge alone.

Stimulating Creativity in Everyone

There certainly remains a great deal to do to improve the cultural participation of a great majority of our fellow citizens. Yet this field remains dangerously neglected by the public powers. It appears that the democratic and humanist arguments are not sufficient to create the pressure needed to change things. Large-scale development and funding of innovative programs destined to increase participation in the arts and cultural life are a long time coming, despite the cries of alarm from researchers who measure the growth of "non-audiences" in cities where the rate of recent immigration is very high, such as Toronto, Vancouver, and Montreal.

Our way of thinking is evolving too slowly, both in the education system and in arts councils, ministries, and municipal services responsible for promoting cultural development. Yet there is wonderful potential, if only in terms of jobs. We need cultural educators and interpreters working in collaboration with the people to conceive and carry out artistic and cultural productions supported by government. We also need a growing number of

artists interested in integrating citizens into their creative work.

The logic of production has been holding sway for seventy years. It still dictates most of the public investment choices in terms of content and infrastructure. I am not suggesting a radical change in policy. If we do not support original, diverse, and abundant artistic and cultural opportunities, we give up defining and expressing our identities. We also leave the field open to cultural production with the markets as the only support. That would jeopardize precious assets for the rest of the world. Art needs more extensive support, but I am convinced we also must stimulate cultural participation going beyond simple consumption. If we don't, we are exposing ourselves to increasingly widening and costly socio-cultural gaps, particularly in big cities. We will also be throwing the subsidized cultural system into a crisis of legitimacy. How can we insist that taxes serve to finance a system that would intentionally advocate the exclusion or ignorance of the majority of the population?

I believe we can advance the cause of cultural participation by emphasizing more the direct impact of developing creativity in every human being. Creativity is a powerful driver of progress and this observation is widely accepted.

Indeed, if we do not generate new ideas and original solutions to our problems, no development is possible. Nor is it feasible to increase the wealth and social capital to share.

There is no doubt that creativity is highly valued. For some years, the quantity of scientific works and discoveries focusing on the relationship between arts and creativity has been exploding. As proof, on Google we find hundreds of thousands of references on the topic. And each time we discover a new source of wealth, disinterested prospectors rush over and generously share their

findings, but are followed closely by less scrupulous people who smell the potential for exploitation and profit. I see ads for seminars and workshops on art and creativity, the prohibitive costs of which are often the most creative aspect.

Creativity is a complex process. It is not imposed by decree. It does not require a diploma or permit, and it cannot be bought. It is not the fruit of a sudden illumination (muses have their limits too), nor is it exclusive to one nation, ethnic group, social or economic group, city, or the spontaneous result of community living. It can only be the result of an emotional, introspective, and intuitive process that derives from the imagination. It is also influenced by context.

Pulling on a flower to make it grow does not make it grow. Creativity has to be cultivated. Any human being's creative capabilities will be stimulated and reinforced by interaction with works of art and cultural heritage because they are pure products of human inspiration and creativity.

Attending and experiencing arts events contributes to the reinforcement of elements that facilitate, enrich, and accelerate the creative process: critical thought, ability to use the imagination on demand, will to transgress rigid mental boundaries, emotional distancing, and the break from conventional and predictable intellectual and physical models. Dance, specifically, develops certain characteristics of creative thinking such as originality, fluidity, and a capacity for abstract ideas. Theatre teaches us to grasp complex issues and makes us think about our fellow human beings' motivations, in addition to sharpening interpersonal skills. Learning music increases the ability to reason and calls upon a kind of abstract thought similar to that required by mathematics.

A few years ago, the Arts Council in England published a guide titled *Reflect and Review: The Arts and Creativity in Early Years*. This guide suggests various simple approaches to developing creativity in children through painting, drawing, photography, music, dance, theatre, and stories. Closer to us, in Canada and in Quebec, we are seeing an increasing number of initiatives along the same lines. For example, ArtsSmarts, an ambitious project funded by the J.W. McConnell Family Foundation, aims to improve learning and creativity in children by integrating artistic activities in school programs.

The correlation between cultural participation and reinforcement of creativity, in all stages of life, has been increasingly documented and demonstrated. For each of us, this is additional incentive to become involved, attending arts events and exhibitions, and encouraging those close to us to do the same. When this is carried through to public policy and large entities such as the educational system, a range of incentive measures for cultivating the arts and other forms of cultural participation is promoted.

The time for this is ripe, as we note by observing what is happening in this area in a very large number of cities in Canada and around the world. Big cities have now become immense open-air laboratories where people experiment with prototypes of social re-engineering. Some of them are called upon to play a key role in reconfiguring fundamental cultural dynamics.

Cities and New Cultural Citizenship

What is currently happening in large cities is crucial for the future of culture and civilization. The rapid and continuous progression

of urbanization is an international phenomenon of such magnitude that it forces us to reinvent living together through restoring the prestige of the cultural dimension.

A United Nations report from 2007 revealed that more than 50 per cent of the world's population is now living in cities. Canada is no exception to this tendency. Far from it. While at the end of the nineteenth century 80 per cent of the Canadian population lived in rural areas, today more than 80 per cent of the Canadian population lives in urban centres.

The planet has 3.3 billion city dwellers, four and a half times more than in 1950, when the rate of urbanization did not reach 30 per cent. The United Nations estimates that more than five billion people will be living in cities in fewer than twenty years, and the rate of urbanization will surpass the 60 per cent mark.

In the twenty-first century, the issue of community living is first and foremost urban, and crystallizes in the big cities, of which there are many: 4 per cent of the world's population lives in the twenty-five megalopolises, bringing together more than 10 million inhabitants. None are in Canada. There are also 440 metropolitan regions of more than a million inhabitants (Canada has six). In addition, 433 metropolitan regions in the world contain between 500,000 and one million city dwellers (there are three in Canada).

Big cities are the first to be affected by this migratory movement. They gain or lose inhabitants according to sudden changes and accelerated transformation in the global economy.

These metropolitan areas contain both fascinating possibilities and serious issues that will have to be taken into account to successfully reconfigure almost all our systems, sorely tested by development that is not yet well mastered. Issues linked to

pollution, litter, public health, transportation, infrastructure, security, multiculturalism, and the struggle against poverty and exclusion are increasing in complexity.

The quality of local governance and political and civic leadership weighs heavily in the balance when it comes to explaining the relative successes and failures of cities, as does the role of national governments. Large cities that are not also political capitals, such as Montreal and Vancouver, find themselves at a disadvantage.

Competition between cities is a reality. This may be in terms of regions, countries, continents, and the planet. We should avoid dramatization, but the competition remains costly for those who are losing at the moment. Cities seek to attract capital, big projects, qualified labour, and tourists. They constantly seek attention and recognition in all areas. The power of a city to attract all forms of wealth is worth its weight in gold. Commercial ventures, poaching, and lobbying are intensifying. Certain cities use remarkable imagination, boldness, and inventiveness in managing to play this game.

Large cities have often been at the centre of the formation of states of which they are a part before being relegated to a situation of fiscal subordination by regional governments. Big political decisions and spending initiatives have often eluded them in many areas, notably in terms of cultural development. This situation persists in Canada. As the great Canadian urban philosopher Jane Jacobs pointed out in her last book, "Yet the anachronistic provincial-municipal wardship arrangements still hold. When the constitution was patriated in 1982 — declared a Canadian instead of a British document — guarantees of basic

civil rights were added, but nothing was done to change the relationship of municipalities with provinces."[45]

Throughout the twentieth century, with a few exceptions, cities have been content to stand by while governments tread water. They encouraged more traditional artistic forms by distributing subsidies or by capitalizing on theatres and museums. They also built and administrated public libraries.

But as I mentioned above, several European cities began to reinvest massively in the cultural field in the 1970s due to urgent concerns of urban revitalization, reactivation of tourism, and economic development. Some centres, which people had scarcely heard of until then, made a clear and conscious choice in favour of the arts and culture as vectors of a new development and emblems of an identity that had to increase their power of attraction and influence. The formula often yielded spectacular results. This movement reached the United States and Canada a bit later. Now it is booming.

We must keep in mind, however, that other cities experience new cultural approaches from motives that were not originally economically based, but definitely political. Indeed, the rise of radical new urban social movements in the wake of May 1968, notably in Europe, led to the election of left wing municipal administrations that modified the cultural order profoundly. This occurred in Rome during the ten-year period following 1976, when the Italian Communist party was in power, and in London at the beginning of the 1980s, when the left wing of the Labour Party was in charge of it. The same phenomenon occurred in many other cities such as Barcelona, Montpellier, and more recently Lille.

The decision to reconsider cities' cultural activities based on a socio-political scale led to several experiments, certain of which continue despite changes in the politics of the governing party. By aligning municipal cultural interventions with urban feminist, anti-racist, anti-poverty, or ecological movements, these governments fostered hundreds of inspiring initiatives worthy of analysis. Several of these attempts concerned cultural inclusion and participation. They would undoubtedly not have come into being had the expenses and investments in culture been completely controlled by national governments proceeding according to traditional logic where creation and production are the engines of cultural development.

The confluence between social and cultural concerns in the 1970s and 1980s, fostered or not by local political will, also boosted the emergence of new artistic practices, certain of which were later recognized by higher cultural decision-makers. Experimental theatre and street theatre, independent documentary film, video art, the proliferation of small publishing houses, the publishing of independent magazines, the opening of community radio stations welcoming new artistic expression, and a host of other phenomena then streamed into the larger cities of the world and prompted an immense cross-fertilization politically, socially, and culturally.

Art came down to the street and street culture changed the "higher" arts and cultural habits.

In cities, naturally, we find large institutions and infrastructures of artistic training, creation, production, conservation, and dissemination. And we find the most favourable conditions for unbridled cultural explosion — which is possibly the most sig-

nificant and durable culturally, sociologically, and economically — in densely populated, very cosmopolitan, and highly diversified cities. Artistic inventiveness and innovation develop and emerge, without warning, from the brains of artists, microcells of creation, institutions of all sizes and the real and virtual corridors of cultural industries. The proximity and availability of resources and the possibility of finding an audience rapidly allow emerging artistic trends to assert themselves. In cities, the non-profit sector and business sectors interpenetrate, while artists circulate — not unlike freely moving electrons. They also move about from one city to another, thanks to a network of festivals and other more or less official channels.

But it is also in metropolises that the issue of cultural participation continues to arise most seriously. The tremendous capacities for artistic creation in larger cities will be wasted and threatened if the majority of their citizens are not interested in them or cannot access them.

Concerted efforts at the local level to increase citizens' participation in the cultural life of a city are a good barometer for the future well-being of metropolises.

This is one of the constants that was observed at the first Universal Forum of Cultures in Barcelona in 2004 and led to the adoption of *Agenda 21 for Culture*, a seminal document.

Agenda 21 for Culture: A Guide for Urban Survival for/in the New Century

In 1992, at the Earth Summit in Rio, the expression *Agenda 21* was first heard. This world plan for the twenty-first century, adopted by the 173 heads of state, emphasized the notion of sustainable

development and the role of local governments to tackle global problems as diverse as health, poverty, housing, pollution, desertification, and management of agriculture.

Agenda 21 for Culture, as its name indicates, deals with cultural development. It was adopted in Barcelona on May 8, 2004 as part of the first Universal Forum of Cultures. It is an important document, due to its relevant observations and practical recommendations. It illustrates to what extent, everywhere in the world, the parameters of cultural development are newly redefined, starting with cities and local governments. Lastly, it argues that cultural development must integrate several imperatives: human rights, diversity of cultural expression, participatory democracy, and creation of conditions for peace.

Agenda 21 for Culture states that cities and local territories provide an excellent forum for genuine reconstruction insofar as people in them decide to promote a creative dialogue between identity and diversity, between the individual and the community. It stresses the urgency of finding a balance between the public nature of culture and making it an institution. It pleads for limiting the role of the market as the sole decision-maker in awarding cultural resources. It reminds people that citizens' initiatives (including that of artists, of course), taken individually or gathered together in associations or social movements is the true foundation of cultural freedom.

Agenda 21 deals with access to culture and the importance of correctly evaluating the contribution of creation and dissemination of cultural property, whether they stem from amateurs or professionals, on a small or industrial scale, individual or collective in nature. It reminds us that culture is a growing factor in creating wealth and economic development. It establishes a list

of thirty commitments that local governments can make to develop cultural policies in the era of globalization.

Agenda 21 for Culture is backed by some 350 cities, local governments, networks, associations, and organizations. More than 125 cities and governments, including Montreal, Toronto, and the Government of Quebec, have officially ratified the document. Its official website, www.agenda21culture.net, presents a "map of the imaginary city" that I encourage you to consult to visualize the labyrinth of networks that make up this movement.

There is still a lot to do so that culture may be considered an essential dimension of our personal growth and our communities' organization, but this understanding is moving forward. We can act locally to change the world, including on the cultural front.

CULTURE AS A HORIZON FOR A METROPOLIS: MONTREAL AS A CASE STUDY

The pressing need to back culture as a sector important to the future and essential as a dimension of our lives and collective plans must translate into reality. Analyses, reflections, and speeches must be convincing, but they are not enough. Sooner or later we will need to have recourse to public and political organization, mobilization, and involvement to instigate the desired changes. One may join the ranks of a political party and seek the support of voters to do so. But one could also choose to act within civil society and question elected officials in power so they make decisions that encourage cultural progress.

The back-and-forth relationship between the civil and political arenas appears essential to succeeding in placing culture at the heart of human and social development in the twenty-first century. For obvious reasons, we must not abandon culture to market forces, nor should the fate of the arts and culture depend exclusively on

elected officials who are in power for a few years. It should not be dependent on the co-operation, confrontation, or negotiation among, on one hand, governments, departments, agencies, arts councils, and cultural services and, on the other, unions, guilds, associations, and service organizations of the cultural sector. The contributions of the latter are legitimate, necessary, and sought-after for the development and good governance of the cultural system, but their logic tends to be sectorially based rather than socially, and more corporatist than common good.

We need to seek a new cultural civic leadership, one that is able to urge artists and conveyors of culture to put effort into reinventing our communities for and with the citizens who live there, over and above their professional and immediate concerns.

Because of the extent of the challenges they must face and the overlapping networks of people and institutions who build them, big cities face sizeable issues for the emergence and exercise of this new cultural leadership, which is needed more than ever. Large cities also offer rich possibilities to experiment with new approaches.

Why Become Interested in the City?

I have always lived in Montreal. I have raised my children here and have worked here for more than thirty years. This is also where the National Theatre School of Canada (NTS) is established, although its students and the artists who are invited to teach here come from throughout the country and sometimes from abroad.

My institutional responsibilities bring me to deal first with the federal government and then with the ministers and the arts councils of other Canadian provinces. In addition, I am involved

at the city level, not only as CEO of the school, but also, for some years, as Vice-Chair of the Canada Council for the Arts. I have long had ties with the Conseil des arts de Montréal, but City Hall has very little to do with my responsibilities. I could easily not have become as involved in the specific concerns of my city. In fact, my engagement in these matters happened almost by accident. I'll come back to that in a few pages.

That said, I have been working for more than twenty-five years in an institution that, since 1960, has trained hundreds of artists and experts in theatre — actors, playwrights, directors, set and costume designers, lighting designers, technical directors — at least half[46] of whom take part in Montreal's creative melting pot, not only in theatre, but also on the literary, musical, circus, media, television, radio, or film scenes. The National Theatre School, like all major cultural institutions, is not only well-established in the city, is also a part of the city's lifeblood and feeds on its artistic vitality.

I did not choose Montreal; it chose me.

It must be said that Montreal has several characteristics that make it an ideal laboratory to test and study the reinvention and reactivation of a big city by banking on arts and culture. Montreal's history, geographic location, distinctive linguistic reality, the diversity and density of its population, the size and vibrancy of its cultural sector, the unstoppable creation of its artists, and civic leadership that asserts itself all come together to foster a creative city that is encouraged to fulfil its destiny as a cultural metropolis and develop and exert its influence on this continent and in the world.

That is what Max Wyman maintains in his essay *The Defiant Imagination*,[47] released in 2004. This book is an impassioned and

well-documented plea to place culture at the heart of the Canadian experience. Referring to the work *Cities in Civilization*,[48] in which British author Peter Hall analyzes the golden age of the five greatest cultural cities in Europe (Athens in the fifth century B.C., Florence in the fifth century, London at the end of the sixteenth century, Paris and Vienna at the turn of the nineteenth century, and Berlin in the 1920s), Wyman tries to draw out certain characteristics present in all these cities at the time they most stood out as cultural metropolises.

I focus on five factors that he mentions: 1) a level of economic strength sufficient for citizens to benefit from the arts; 2) a high degree of civic pride; 3) the fact that the city is going through profound economic and social transformation, creating an atmosphere of uncertainty that stimulates research and creation; 4) the possibility of making chance intellectual discoveries due to the density of the urban population and the constant circulation of foreigners; 5) the presence of many creators drawn to the city who reject any limitations on their artistic freedom.

Wyman continues his reflection by attempting to see if such characteristics are found in Canadian cities so as to evaluate their likelihood of achieving a cultural golden age. He states that Montreal, especially in the period from 1960 to 1990, emerges as the city that approached this the most closely. Wyman supports his claims with several observations. Of course, he mentions the momentum of the economic and identity-based affirmation and emancipation from the hold of the Catholic Church prevalent in Quebec, and especially in Montreal, at the time of the Quiet Revolution[49] and of the policy of *"Maitres chez nous"* of the government of Jean Lesage.

He stresses the consciousness-enlightening role played by the Montreal artists surrounding Paul-Émile Borduas, who, in 1948, signed the declaration *Refus Global*.[50] He continues, explaining the extent to which Montreal's playwrights, songwriters, filmmakers, writers, visual artists, and choreographers were in symbiosis with the popular emancipation movement that marked the 1970s. He also emphasizes the numerous relationships forged as of the 1940s between Montreal's artistic community and artists from France and countries in Eastern Europe. He speaks of their direct influence on artistic creation stemming from the city. Wyman says the relationship established between the general population and several renowned and influential artists created a situation equalled nowhere else in the country. He also notes that the Quebec government's financial support followed and that the Montreal business class had a certain consciousness of cultural issues.

Observations made by Kevin Stolarick and Richard Florida in the studies they carried out in Montreal in 2004[51] also confirm that Montreal has qualities that make it a possible major creative city in North America. Indeed, researchers emphasized that Montreal is third in terms of population density among the twenty-five large urban agglomerations in Canada and the United States, surpassed only by New York and Boston. Montreal ranks second among these large agglomerations in the most number of jobs in creative areas. The combination of urban density and concentration of its creative sector produces major advantages in terms of interactions leading to innovation. Stolarick and Florida also emphasize that Montreal's linguistic situation — the predominance of French and the functional bilingualism of the

majority of citizens — as well as its geographic location make it a bridge between Europe, Canada, and America. Their report points out the exceptional vitality of Montreal's artistic underground, which acts as an incubator for new trends as it is in sync with the concerns of youth, while taking advantage of the advantageous material conditions for independent creators such as the large number of rehearsal halls, studios, and stages available at low cost.

Of course, I could try to describe and make an inventory of several other characteristics of Montreal, but for now I will stick to these observations by outside observers to state that the political and civic efforts intended to make Montreal a cultural metropolis are not immediately condemned to failure, but quite the opposite.

The city's history, particularly the dynamic established in the two decades following 1960 between its artists and its general population, as well as the constant convergence of social transformations and cultural movements, leads us to believe that the dream of making it an exemplary cultural metropolis can still materialize.

But this dream still needs to be reactivated in the cultural sector and among Montreal's artists, and it needs to be supported by other sectors of the city, and it must be a dream shared widely by the citizens. It must also be translated into action, thanks to the convergence of political and civic leadership that the city possesses.

How can we achieve this? That question became the main theme of a personal commitment and a collective journey that I will comment upon in the following pages.

Constructing in a City

In the spring of 1993, my time and energy were taken up by the restoration site of the oldest theatre in Canada still intact, the Monument-National. We were in the home stretch of a race against the clock begun eighteen months earlier. The renovated building had to reopen in the summer. Deadlines and budgets were tight and unexpected events piled up. The pressure was increasing with each passing day. I had many long hours to work, but I was under forty years of age and had energy to spare.

In the eyes of the architect, engineers, set designers, and site manager monitoring the work being carried out, I was the client. Indeed, for close to two decades, the National Theatre School of Canada had owned this building, which was over a hundred years old and located on boulevard Saint-Laurent, in the heart of the red-light district.

That year, there were very few cranes on the Montreal skyline. The big real estate projects connected with the recent 350th anniversary had wound up. The days following the celebration were not glorious. The public financial crisis and an anaemic economy contributed to the morose climate that hung like a dead weight over the city. Politicians held forth on the lack of productivity. Employers' spokespersons pointed the finger at government waste and overly high taxation rates while proposing the end of the welfare state. Management specialists handed out their prescriptions for scaling back the public service and private companies. Montreal's official unemployment rate hovered around 14 per cent and the Conseil du patronat claimed that the actual rate was closer to 23 per cent. Once considered Canada's only metropolis, Montreal had now become the fragile metropolis of only the province of Quebec, and was in a bad way.

Given this context, I was even more conscious of my good fortune and my responsibility. I had just been promoted to the administration of an art school I had come to know and love in the last ten years. Inspired by the vision and efforts of my predecessors, I jumped on the bandwagon for renovating the Monument-National. Indeed, they had already made a first official announcement of this project in 1989.

I found myself at the heart of one of the rare construction projects then underway in Montreal. Daily contact with the architect and the site manager to monitor the work was stimulating and instructive. Though I was unfamiliar with the field, I learned from the experts. Each decision or correction to the plan required immediate action, and thanks to the workers' expertise I was able to understand rapidly the needs and implement the action. The organization and workings of a construction site were light years away from a theatre school. In the latter, intuition, inspiration, and beginning over are at the heart of learning and creative processes.

I was fascinated by the very history of the Monument-National, which allowed me to discover Professor Jean-Marc Larrue, who helped us to document the feasibility study for the renovation and who was preparing a book[52] on this building. The Monument-National was constructed by the Société Saint-Jean Baptiste de Montréal in 1893. Designed at the outset as a cultural and social centre, the Monument-National has become a showplace for the performing arts, and a kind of open university. In delving into the files, we discovered that it had been the crucible of the modernist movement in Montreal. The fine arts, diction, and economics were taught within its walls. The city's first feminist associations and artists' unions gathered there. Orators

of all political leanings harangued crowds in its large auditorium. Thanks to a rental agreement concluded in 1897 with Louis Mitnick, director of a Yiddish theatre, the monument became a major Jewish cultural centre. Some seasons, a Yiddish play was performed each night of the week and all the great stars of the American theatre trod the boards of the Ludger-Duvernay auditorium. I realized that the Monument-National was a lot more than just an old theatre and it would be important to find a way not to erase its history while adapting it to the school's needs.[53]

I also learned very quickly about my own city. Everything more or less on the periphery of this site, located on the most dilapidated stretch of a mythic thoroughfare of the metropolis, was a source of learning. I was in contact with the neighbours, community groups, social workers, and merchants. I heard them voice expectations and express their hopes in terms of our project and its possible impact. I began to dream that such a cultural initiative could re-energize this part of the neighbourhood of lower Saint-Laurent, now fallen into disuse, by acting as a reminder of its glorious past and as a beacon for the future.

Several years later, I saw Club Soda (2000) and the Société des arts technologiques (2003) set up across from the Monument and learned of the real estate projects of Angus Development Corporation[54] (2009). I came to realize that revitalization of this area required effort, financial investment, political rallying, and good will that were far more substantial than those that we had managed to mobilize at that time. But we had to start somewhere.

Héritage Montréal: An Inspiring Partner

Before work on the site began, I met, for the first time, representatives of Héritage Montréal, an organization that is a beacon in

protecting and enhancing the status of heritage buildings. It does so despite a great deal of resistance in a city that too often unrealistically tries to move towards its future, neglecting its past. The founders of Héritage Montréal played a key role in 1976 in encouraging the Government of Quebec to classify the Monument-National as a heritage building and to establish a protected area around it. This status saved the historical building from speculators, developers, and the pickaxes of demolition workers. Héritage Montréal was an essential ally in carrying out the project for renovating the Monument. Its leaders, including Phyllis Lambert and Dinu Bumbaru, greatly impressed me. In addition to their expertise and knowledge of the city's history, their staunch determination struck me. They did not hesitate to fight in the trenches with citizens and representatives from the city's socio-economic community when necessary. I saw this as I watched the news describing the struggle to save a hospital from closing. These people were in the line of fire. In many cases, they intervened in the public arena while increasing effective representation in the halls of power; they also worked continuously to educate and sensitize their fellow citizens, the owners of the buildings, and the media. I was keenly interested in this model organization that bridged the gaps among academics, specialists in architecture and urban planning, elected officials, and citizens.

Today Héritage Montréal is still the watchdog for responsible urban planning. Its vehement protests often disturb developers, who accuse it of dogmatism. Montreal owes a lot to this organization's activism. The city planners of Toronto and elsewhere remind us of that from time to time, rather enviously.

Alternate Views on the Same Project

Several months before the building site operation began, I took part in lively discussions with small theatre companies in Montreal, who were disappointed to see $16 million of public funding allocated to renovating a building belonging to a theatre school. Admittedly, at that time most of these companies were in a state of relative poverty and had no fixed abode. We earned their support for the renovation by adapting our initial project. After hearing them, we committed ourselves to welcoming profes-sional theatre companies to the new Monument-National. The architect had to revise his plans; he had to add a ticket office, a coat check, a bar, and other related services. What had been intended as a pedagogical tool reserved for the quasi-exclusive use of students of the National Theatre School became, on June 21, 1993, an open cultural complex where training, production and presentation of the performing arts coexisted. So much the better.

I also took part in complex negotiations with the governments of Quebec and Ottawa to finalize funding agreements. The economic situation at the time did not encourage major projects. We had to cite urgent circumstances such as the threat of the fire department shutting down the building and risks related to the safety of passersby caused by the crumbling facade. Of course, we had to highlight the National Theatre School's needs and bank on its reputation for excellence. But those arguments were not enough: we had to develop a socially and politically defensible cultural project at a time when hospitals were being closed.

I observed and began to understand how cultural bureaucrats evaluated a project's economics and how they determined its

worthiness based on their own funding program's goals and objectives. Coinciding with these administrative processes, the many meetings with political staff and the ministers concerned before and during the construction enlightened me as to how they constantly seek to reconcile short-term goals with a future they are never certain to be a part of, due to elections.

Pre-eminence of the Human Factor at All Times

The Monument-National could not undergo the makeover so desired without substantial contribution from the private sector. This indispensable condition was imposed by both governments. So I began this phase of my career by seeking donations and sponsorships, a prerequisite for any leader of a cultural organization.

While work progressed on the site, I toured private foundations and large corporations in the city with members of the school's board of governors. I quickly realized that there, as elsewhere, the human factor prevailed. Performance calculations based on sponsorships and compliance analyses for the donor company's policies are certainly prerequisites, but emotion, passion, and personal preferences weighed heavily when the moment of decision arrived.

I came to understand this best at a meeting in the offices of Imasco in the fall of 1992. We had been negotiating for months with this company, which is headquartered in Montreal and holds two-thirds of the cigarette manufacturing market in the country. We asked them to sponsor a studio-theatre located in the basement and on the main floor of the Monument-National. Members of the school's board of governors had made representations to the leaders of Imasco. Our file was making its progress

through Imasco's internal systems, but many details had to be settled before an agreement could be signed. This was the context for our meeting with the director of sponsorships and donations. I had done my homework and knew that Imasco had recently made a major donation to build a theatre on the shores of Lake Ontario.[55] I also had statistics in my head on the consumption of Imperial Tobacco's products in Montreal and intended to use this argument if given the opportunity. Their assistance would be essential to wrap up the works; we were hoping to receive a substantial donation. In fact, no Montreal theatre to date had ever received such a substantial sponsorship.

The meeting began and very early in the conversation the director confided to us that her mother's family had subscribed to the seasons of Les Variétés lyriques presented at the Monument-National in the early 1940s. She added that her mother even had to leave the Ludger-Duvernay auditorium prematurely after the first act of a show in order to give birth to her in a neighbourhood hospital. The rest of the meeting took on a different colour. Need I add that Louise Rousseau then helped us settle all the details of an agreement of mutual benefit to Du Maurier and the school? I learned my lesson: you have to be interested in whom you're talking to, instead of only concentrating on your message. Involving people is important.

In retrospect, I realize that my participation in the project of rehabilitating the Monument-National was key in my commitment to Montreal's cultural and civic dynamic. It allowed me, in a very short period of time, to meet dozens of active, interested, informed, and influential people in the city and to begin to forge ties with them. I understood the crucial importance of networking

with people. It made me realize that culture is a recognized calling card and a way of urging individuals belonging to various communities to imagine the city differently.

Gaining a Real Citizenship

Two months before the official inauguration of the restored Monument-National, the president of the school's board of governors, Bernard A. Roy, suggested I attend an international conference on managing organizations to be held in Montreal. He saw in it an opportunity to fuel our reflection on the necessary reorganization of the National Theatre School's administration prior to reopening the Monument as a centre for training and as a performing arts centre. The keynote speakers — among them Hervé Sérieyx and Albert Jacquard — were renowned for their publications or were leading or advising multinational companies such as Hewlett Packard, Xerox, and FedEx France.

The speakers followed one another on the podium, each in their own way emphasizing the importance of reformulating mission statements and giving them meaning so as to mobilize teams in companies that had undergone a succession of mergers, acquisitions, cutbacks, re-engineering, and restructuring. I listened to their words and thought of the paradoxical situation in the cultural community. Our organizations probably did not need such a reorientation operation: cultural organizations had no problem convincing their staff of the validity of their mission. Rather, they were grappling with an excess of direction, values, ambitions, and visions thanks to the artists and creators who led them. The deficit, of course, was in terms of financial and organizational resources.

Halfway through this conference, which brought together

over a thousand people, we were asked to participate in an interactive, live poll. One of the conference sponsors likely wished to promote his new technological tools. A goal was to determine, in real time, the work experience of the participants. It involved each person simply pressing on a remote control to indicate their level of responsibility within the company and their area of activity: finance, health, construction, education, civil service, business services, etc. There was no category for arts and culture. I worked in an area not important enough to be identified by category. I, who was beginning to convince myself that we were able to contribute to the quest for meaning and values that now seemed so urgent in all the other sectors.

During the break following this survey that classified me in the all-encompassing "other" category, I shared my impressions with two conference participants I scarcely knew, but whom I knew belonged to my sector. The regional director of the ministère de la Culture, Robert Fortin, and vice-president of public and social affairs at Cirque du Soleil, Gaétan Morency, shared my diagnosis: the cultural sector was not experiencing the same crisis in values the speakers were describing, but was suffering from a glaring lack of recognition. We hypothesized that perhaps we were in part responsible for our own misfortune: we had a tendency to remain among ourselves, which condemned us to remaining on the margins of society. We told ourselves it was high time to let the other sectors know we existed and could be stakeholders in the solutions to management and mobilization problems being analyzed at this conference.

This brief exchange would be the beginning of a completely different type of structural foundation than the one I had managed to extract myself out of the forty-eight-hour conference — a

foundation begun without specific plans due to a lack of competent and available architects and engineers. Intuition and motivation allowed us to create preliminary sketches together. The construction would be collective and based on our evolving reflections and the prevailing strengths. This construction plan, one without a set deadline, consisted of creating a new cultural leadership in Montreal. This process is still active as I write these lines, and no doubt will be for a long time.

The Genesis of the Organization Culture Montréal

Some time after this impromptu conversation in a hotel corridor, the three of us agreed on a very simple initiative to advance the thinking we had just begun. We would organize informal meals in our respective offices and apartments to encourage meetings and discussions on the role and contribution of the cultural sector in the metropolis. We sought to fill a leadership deficit, but first had to approach people and assess their willingness to commit. Those approached were active on the Montreal cultural scene — artists or managers who wanted to do things differently and were likely to be interested in more territorial than sectoral or discipline-based issues.

The core of the group was quickly established. To this were added people from various walks of life. There were, of course, varying degrees of participation, but the affinities observed at the first meetings were enough to get us started. We decided to name and structure the process by creating the Groupe Montréal Culture (GMC).

From the start, we had a wish that became our central thesis: the cultural sector should seek to contribute to society instead of

making demands of it. By demonstrating our will and ability to participate in the economic, social, and cultural development of the city, our sector would be recognized, its needs considered, and its requests supported by others. The city appeared to us as an ideal place to adopt this new strategy because it gave us proximity and daily collaboration with other stakeholders.

The issues debated within the GMC first centred on the cultural community's interactions with the city. We had to engage with municipal reality. We read numerous reports from the advisory committees examining the city's economic and social situation over the last twenty years. We subscribed to the observations that emerged on the slow decline of the metropolis that began almost three decades before.

We had to face facts: Montreal had not been Canada's metropolis since the beginning of the 1960s, when Toronto began to stand out as the major Canadian metropolis. Montreal had largely earned this status thanks to its transportation infra-structures and heavy industry, the growth of which had been overstimulated by the war effort, but which were becoming increasingly obsolete in the modern economy. The city's financial sector had been decimated for a few years as several headquarters moved to Toronto or Calgary. The economic strategies put forward to halt the city's decline only worked partially, or not at all, due to a lack of a realistic vision. The Montreal-Mirabel Airport and the Olympic facilities were constant reminders of this reality. The forecasts that demographers were revising downwards painted a dire picture of Montreal's future.

In the beginning of 1994, Montreal was, at most, the metropolis of Quebec by default. A discredited metropolis, not loved enough, and isolated. The business community had to beg politicians to

acknowledge that Montreal was the economic engine of Quebec. They wanted the metropolis to be known as an "international city" and conferred upon it special linguistic status. David Powell, the first president of the new Board of Trade of Metropolitan Montreal,[56] was quoted in the daily newspaper *La Presse*: "Our members are urging us to be proactive, rather than reactive, to take charge of the development of Montreal. The best salespeople for this are often the entrepreneurs who do business in the city."[57]

Montreal's economy, institutions, and population were changing rapidly, but it was still very difficult to detect a glimmer of light at the end of what had become a tunnel. The provincial government rationalized its expenses. Times were lean, and this intimidated people who might be willing to think of launching new initiatives. The imminent closing of seven hospitals had just been announced. The Montreal metropolitan area came last out of twenty-four North American metropolises in terms of job creation. Poverty was on the rise and eating away at areas where it had had less of a hold in times past, such as Villeray, Ahuntsic, and Rosemont. Retail sales were stagnant, commercial and personal bankruptcies were rising, and personal debt-to-income ratios were reaching historic records. The overall portrait was far from bright.

The Cultural and Community-Based Exception

Despite everything, Montreal still distinguished itself from other North American cities through the exceptional dynamism of its cultural sector and the innovative nature of social and community-based entrepreneurship emerging in its neighbourhoods. That said, leadership appeared much more assertive among community activists than in the cultural sector. This leadership

mobilized people and intervened. It had a public, political, and social impact. We had proof of that in 1995 with the success of the Bread and Roses March[58] led by Françoise David, and the creation of the *Chantier de l'économie sociale*, led by Nancy Neamtan.

My colleagues and I were persuaded that Montreal's destiny would be that of a cultural metropolis thanks to the creative energy of its artists and the exceptional cultural entrepreneurship demonstrated there, notably with the rise in the number of festivals and the emergence of Cirque du Soleil as an international success, with shows presented in many countries around the world.[59] We also emphasized the strength of the Montreal cultural ecosystem, which included training, research, creation, conservation, production, dissemination, and export. We cited the exceptional influence of artistic creation that emerged from our city onto the world stage.

But we also admitted straightaway that if the city continued to stagnate economically and be marginalized politically, its cultural vitality would be seriously damaged. Inventiveness and resilience have their limits.

What to Do?

We then tackled the questions of "what to do" and "how to do it." How could Montreal halt its decline and revive its status as a metropolis? How could the cultural scene allay itself with the social, economic, and community-based forces also seeking to rebuild its future? How could we affirm that the Montreal cultural sector had to go from making a lot of demands to making contributions without alienating several Montreal leaders at the heads of unions and associations, who were first and foremost interested in the conditions in which artists work?

It was not easy to come up with convincing answers to these questions. We had been exchanging notes and books for two years, and we had studied various models for urban regeneration in which the cultural factor played a constructive role, such as Boston, Pittsburgh, Bilbao, Glasgow, and Dublin. We also attempted to map the Montreal cultural sector so as to locate leaders to give impetus and support to such a dynamic. Our criteria were simple: we were looking for individuals concerned by issues that extended beyond their own organizations. We identified members of boards of directors and leaders of cultural organizations likely to be interested in the debates we wished to raise.

As the months passed, we developed a common vocabulary and ways to intervene. We expanded our networks. We initiated and carried on multiple conversations with researchers and scholars. We also forged international connections. Inevitably, both City Hall in Montreal and the Government of Quebec began to notice our group's existence and to become aware of some elements of its intentions.

But to avoid a cliquish mentality, and above all, to be consistent with our intent change things, we decided to open up and broaden the process.

Taking Action

Between 1996 and 1999, the GMC organized thematic meetings in which between 100 and 150 stakeholders from the Montreal cultural scene participated: artists, leaders of organizations, academics, cultural experts, and civil servants from governments and the City of Montreal. To emphasize our bias in favour of taking action, these meetings were announced as the *Forum*

d'action des milieux culturels du grand Montréal (*Action Forum of Cultural Communities of Greater Montreal*).

The *Forum* meetings focused on the definition of the concept of the metropolis, international influence, and municipal organization. We invited speakers likely to help advance the thinking and stir debates, as is customary in all meetings of this type.

But, from the time of the first *Forum*, we made innovations by inviting participants to take concrete action. Above all, we did not want to transform what had more or less become a club for discussion (the GMC) into permanent group therapy for the cultural community. We therefore proposed analyzing the political climate and identified the events and dynamics considered essential on the cultural scene. We decided, for example, to take part in preparing the Government of Quebec's *Sommet sur l'économie et l'emploi* (*Summit on the Economy and Employment*) in the spring of 1996. Premier Lucien Bouchard[60] invited all the stakeholders of civil society, notably CEOs of large companies, associations of employers, unions, and representatives of large social and community-based movements. But there was no cultural delegation as such, nor even any specifically cultural projects announced, except for the idea to create a new tourism event that would later become the Montreal High Lights Festival (*Festival Montréal en Lumière*).[61] We thought it important to present an emblematic cultural project that would have long-term impact at a time when people were choosing the kind of society they wanted. We were very aware of the importance of networks to which *Forum* participants could have access. Leadership is also measured in terms of influence.

Preparing and facilitating the meetings of the forum forced

our original group to expand and come up with new ideas. Several people collaborated with us, sharing their experiences and perspectives. We had to assemble our thoughts and practise the art of persuasion and mobilization. The spontaneous response of a good number of Montreal cultural stakeholders was very positive. We got together each time we felt the need to debate questions that affected us. Above all, we felt a need to unite to become part of the urban, economic, and social debates to which the cultural community was too rarely invited or in which it was not used to participating.

What Leadership?

Each meeting of the expanded *Forum* was an opportunity to express ideas and to formulate new proposals. Some came to pass, but most of the good ideas simply vanished because we were not organized well enough to implement them. Issues of following up and leadership resurfaced time and again.

Members of the core group, however, were unanimous in pleading for an organic process. We opposed the logic of hierarchical or elective forms of organization. We certainly did not want to become mired down in a formal decision-making processes. Knowing the cultural community was splintered and very competitive, we sensed that we could not achieve unity without compromises we did not want to consider. We sought new modes. We advocated a rotating leadership of the available talent based on the changing needs of the organization. We wished to be inspired by the type of leadership and organizational structure of the new social movements. We observed the rise of anti-globalism and the brilliant successes of the ecological

movement then taking off and were interested in the new forms of organization and communication arising from them. We wanted to provoke a wave of change within the Montreal cultural scene, not create another structure.

But this idealist and spontaneous discourse reached its limit in early 2000. We were up against a wall. It was obviously difficult to ensure continuity of the *Forum*'s occasional meetings. Even the people associated from the start with the *Forum d'action des milieux culturels* were beginning to doubt its relevance and effectiveness. There was a risk of apathy and dissipation of our energies. Certain people discussed the possibility of creating a new municipal political party that would be to culture what the Greens were to the environment.

We had to find a more evolved and effective form of organization. Time was wasting.

Gathering Together Montreal's Cultural Communities

In January 2001, we hired a co-ordinator to lead a project that we called "Culture Montréal." We selected a young visual and media artist with previous experience as a cultural organizer. Eva Quintas was a part of Montreal's community of emerging artists and identified with it. One of her most significant contributions to the spirit of the process underway stemmed from her critical stance vis-à-vis the large organizations and associations at the top of the cultural system, such as the National Theatre School, Place des Arts, the Montreal Museum of Fine Arts, the Cinémathèque, Cirque du Soleil, and Union des artistes. Eva Quintas would often keep us on our toes by reminding us that certain of our positions were not unlike those of a cultural and generational elite from

which we wanted to distinguish ourselves. It would be profitable, as critical thinking always is.

We announced we would hold twelve meetings, brainstorming and consulting with professionals from theatre, dance, music, architecture and urban development, history and heritage, visual arts, media art, film and television, literature and publishing, multimedia and new media, the recording and entertainment businesses, and interdisciplinary and intercultural practices. We tried to investigate various components of the city's cultural sector. Close to 150 people accepted our invitation to work on a document entitled *Culture Montréal: Pour un rassemblement des milieux culturels de Montréal* (*Montreal Culture: For a Unification of the Cultural Sector in Montreal*).

Each meeting began with the presentation of a few observations regarding the cultural community's poor presence in the major debates and movements shaping the city. To change this, we proposed that artists and cultural workers become interested in issues of identity, heritage, artistic creation in the city, citizenship, urbanism, metropolitan governance, and new means of funding culture. We also sought advice for the plan to create a non-partisan citizen's organization, based on ideas, proposing a broad vision of cultural development for Montreal, invested in the new city's collective issues. The structure and organizational methods aimed to be receptive, flexible, and inclusive. Our membership had to reflect openness to all communities and people concerned with cultural development.

Each meeting allowed us to adjust our proposals and to modify our assertions. But we felt a strong movement in favour of the approach we were taking. Montreal could well be on the cutting edge of the necessary reconfigurations of relationships between

culture professionals and the citizens in a metropolis.

On June 20, 2001, we convened a plenary assembly at the Bonsecours Market in Old Montreal to report on the results of the consultation process and to contemplate what would come next. The debates were somewhat stormy. Certain participants were skeptical regarding the possibility of creating an organization with the primary mission of making proposals, since membership would not be limited to professionals only, and it would not function on the model that had long prevailed in national arts organizations. Culture Montréal did not yet exist and already was shaking up long-ingrained habits and behaviour in the Quebec cultural community.

Despite the concerns and opposition expressed, the plenary session concluded with a majority vote in favour of creating an assembly of people in the cultural community. The ins and outs of the platform and the principle of individual, open membership applications were supported. People also voted in favour of holding the Montreal Culture Summit in October 2001. This summit was to be the opportunity to discuss a strategic plan and adopt the position for creating Culture Montréal.

It should be said that the political context that then prevailed led to a reconfiguration of forces. The Government of Quebec had just passed Bill 170, which forced the merger of twenty-nine municipalities on the island of Montreal. A municipal election was to be held on November 4, 2001. Everything led us to believe that we were on the brink of a historical moment. Montreal was getting ready to resume its destiny as a metropolis. Cultural issues could be brought to the forefront — if we organized ourselves.

Culture at the Summit

On October 20, 2001, the Culture Montréal summit opened in the large auditorium of the International Civil Aviation Organization (ICAO). The organizing committee did not choose this place by chance: it was the privilege of a metropolis to house international organizations.

We had been circulating the content of the announcement since early fall, which we had published in newspapers. It had been noticed and caused a lot of talk in the cultural community. Under the title "Culture is Everyone's Business!" we had announced a free event open to anyone interested in culture and Montreal's development. We invited people to participate in a forum to adopt an action plan for culture in Montreal and create an organization capable of translating it into action: Culture Montréal. We also announced a discussion on culture, the city, and the citizen, and a presentation of international models of cultural cities. Finally, we announced that the summit would be an opportunity to hear the two main candidates for mayor defend their points of view on the role of culture in the new City of Montreal. Quite a program for just one day. We hoped not to put people off.

But our approach turned out to be the right one. Approximately four hundred people responded to the call — most of whom were people we did not know. We had finally emerged from our limited group of regulars. The crowd rushing to register for the summit was different from the one that had attended our consultation the previous spring or the *Forum d'action* of cultural communities. Questions from the audience confirmed this to us in a few hours. There were teachers, bar owners, art lovers, retirees, musicians from the alternative scene, and cultural civil servants

from the cities that would soon be amalgamated. That morning, inside the walls of ICAO, were people from different generations, clearly reflecting Montreal's diversity. There were also, of course, many professionals from the cultural community, including several known figures such as the president of the Union des artistes. Excitement was in the air.

The opening address was given by Canadian Robert Palmer, an international cultural expert, who at that time was director of Brussels 2000, that city's showcase year as European Capital of Culture. Speaking from vast international experience and participation in various attempts to reposition cities using cultural strategies, Robert Palmer was quite categorical. He stated that regardless of our analysis of Montreal's cultural situation, the upcoming municipal election result, and the form of the organization we would choose to create, we would not succeed unless we were well grounded in our reality and our distinctive identity. We might be inspired by what was being done elsewhere, but we had to find our own way. The discussion he provoked was fascinating. Already we could see that Culture Montréal would be internationalist while being in line with local reality.

At the end of the morning, the mission statement and organizational structure proposed for the new organization were presented in a plenary session prior to workshop discussions. Culture Montréal's proposal was expressed around three main objectives: 1) access to culture for all citizens of the city; 2) taking into account culture and all aspects of the city's development; 3) the affirmation of Montreal as an international cultural metropolis. To ensure permanent implementation of this program, we proposed that Culture Montréal gather together, inform, and sensitize people, and intervene publicly. The organizational

structure selected had to foster civic and individual commitment. Everyone could be a member provided he or she supported the objectives of Culture Montréal and paid dues. For it to function as democratically as possible, leaders would be directly elected by individual members.

Both the workshops and the plenary discussions on the program content and means of intervention went well. Predictable tensions were expressed regarding the definition of culture. Certain people were afraid that such a broad concept would mean diluting specific issues in the cultural sector. When the debates wound up, people were largely in agreement with the proposed platform and means for funding, though they could, of course, be perfected.

The debates turned out to be much more difficult and even acrimonious at times regarding the proposed organizational structure. Some representatives of national professional associations argued firmly that Culture Montréal should not be such an open organization. They feared that including citizens and rallying leaders of socio-economic communities would end up marginalizing the demands for improving the conditions in which artists lived and practised. They wanted a territorial structure representing only the professional interests of the cultural sector. Of course, we responded that this would be contradictory to the program and the very objectives of Culture Montréal. We emphasized that many associations and unions aiming to defend the rights of their members already existed. Culture Montréal would recognize their contribution and collaborate with these organizations each time it was relevant, but we pleaded passionately for a new model, for a committed citizen-centred approach. This plea was greeted positively by the large majority of participants, even if some

stood their ground. It did not prevent participants at the summit from voting massively in favour of creating Culture Montréal.

An Expected Birth

In the months following this symbolic founding, more than two hundred founding members of Culture Montréal assembled in eight committees to develop its platform by delving more deeply into topics such as the emergence of new artists, artistic practices and technologies, arts education, cultural identity, democracy, economics, artistic plans to drive the new city, and the amalgamation of the municipalities on the island of Montreal. A strong wind of renewal was blowing. People enthusiastically alluded to Porto Alegre[62] to acknowledge the hopes this process raised and the citizen-centred, inclusive spirit that characterized it.

The organizing committee continued its work until the official founding meeting held on February 28, 2002. In the public notice of meeting, people were reminded that the "Sommet de la culture supported the project to create an open, trans-disciplinary, trans-cultural organization, the structure of which must also be as fluid as the cultural phenomenon itself." It was also stated that "Culture Montréal is an invitation to rethink discipline-specific issues and equity between arts and culture organizations, to make culture a factor of collective enrichment."

At the time of its founding meeting, Culture Montréal had 325 paid-up members. Approximately forty of them ran in the election for seventeen vacant positions. The first board of directors was made up of a majority of people who had never met one another before the new organization was created, although most of them had jobs in the cultural sector.

News of Culture Montréal's creation spread like wildfire. The originality and openness of its platform intrigued people. In the three months following my election as president, I gave five major speeches at conferences in Montreal, Toronto, and Moncton. One of the conferences, organized by the Montreal Board of Trade, was entitled *Montreal 2017: A 375-Year-Old City*. We realized this organization that brought together the economic communities of the city was preparing to take a cultural shift.

In little time, we recruited new members from the cultural sector and from the general and business communities. Culture Montréal's open dialogue was successful. The media, as well as politicians, were interested.

Baptism of Fire for Culture Montréal

In May 2002, the mayor of Montreal, Gérald Tremblay, asked me to chair the cultural delegation on the occasion of the Montreal Summit to be held from June 4 to 6, 2002. This summit aimed to establish the priorities for the newly amalgamated city. This very strong and relatively ecumenical delegation brought together a large number of the city's cultural leaders, some of whom were openly opposed to the founding of Culture Montréal and created a parallel organization, the Conseil de la culture de Montréal. This became the opportunity to try to convince our unconvinced colleagues that we needed to develop a common dialogue capable of integrating all our differences, however slight. Our differences were not so fundamental. We had to be united if we wanted to influence the destiny of the new metropolis.

At its first meeting, held in late May, the cultural delegation agreed to set out its actions at the Montreal Summit in terms of

five major themes: the cultural metropolis, development of cultural life, cultural diversity, cultural democratization, and participatory democracy. Members of the delegation also decided to back at least four big projects: the Cité des arts du cirque, the Quartier des spectacles, a significant increase for culture in the municipal budget, the mandate and independence of the Conseil des arts de Montréal, and finally, improvement of the network of libraries, maisons de culture, and cultural centres across the Island.

In the press release issued the day following the meeting, Culture Montréal declared, "In the context of this Summit, we must favour a global approach and not become entangled in details or become embroiled in narrow special interests. We must count on patient work involving explanation, be able to listen and forge alliances with other delegations to build the new city. The delegation has the expertise, talent, and passion it needs to let the vision of a dynamic, inclusive cultural metropolis emerge, able to assert ourselves internationally."

The Montreal Summit gathered together more than one thousand people from the twenty-seven boroughs of Montreal; these people were grouped together in fourteen delegations representing all fields of activity and segments of the population. The exercise consisted in setting out priorities for the new City of Montreal.

But the process of creating this event was long and somewhat chaotic. Journalists' scepticism regarding Mayor Tremblay's risky enterprise was obvious.[63] In the end, the summit was a successful initiative because it mobilized forces. The cultural delegation was no stranger to this success. Indeed, it managed to play an active and unifying role at the 2002 summit. Its presence was appreciated by the other delegations and by the political observers present. Its

statements and its work were noted in the information provided to the media. The concept of Montreal as a cultural metropolis had succeeded. The project to create a Quartier des spectacles won support from the economic, social, and political communities. We also intervened in debates on land development, education, housing, and safety.

The dynamic of persuasion and coalition that prevailed during the three days of the summit allowed the arts community to establish a lasting foundation for alliances with delegations from the worlds of business, community development, etc. These alliances were consolidated in various ways in the wake of the summit, notably in the subsequent meetings created by the mayor, in which he brought together approximately thirty people who had acted as leaders of sectoral delegations during the summit.

A Catalysis of Leaderships

The cultural delegation's unquestionable success weighed heavily in the balance when it came time to settle differences with the opponents to the creation of Culture Montréal.

Culture Montréal's platform and the principle of individual memberships remained intact, but we agreed that the majority of those elected to the board of directors should come from professional ranks. The compromise was honourable; the open wound of the metropolis's professional cultural communities was closed, and healing could begin. The future looked promising.

The capital of credibility accumulated by Culture Montréal in less than a year of its existence was significant. It came to be perceived as a major stakeholder, city-wide, by the general population and the provincial and federal governments, as well as international associations and organizations.

Culture Montréal did not seek to defend only its members' own interests. It defended the idea of a city in which the arts and culture played a major role in the lives of its citizens, and in the development of citizenship itself. This positioning allowed Culture Montréal to inform and motivate the municipal leadership instead of attempting to wield some sort of power itself or demand legitimacy. Culture Montréal was not substituting for another organization, and did not usurp any responsibility or prerogative, or act on behalf or in place of any particular sector. It was an open and accessible vehicle that pursued a large, fundamental shift that promoted the reinvention of the metropolis through the arts and culture.

Due to its mission and composition, Culture Montréal had no other choice but to give priority to the authority of argument over the argument of authority: we were not an officially recognized organization. This was an area of debate and discussion. It was also, perhaps above all, a tool designed to lead to collective action. We would have the opportunity to learn to use it in all sorts of circumstances in the four years that followed.

Indeed, the new City of Montreal went through stormy times, forcing us to refine our methods of action, uniting with other associations and modifying various aspects of our mission. The municipal demergers of 2004, the strong subsequent decentralization of powers of the former City of Montreal to the boroughs, and the changes of government in Quebec City and Ottawa, led us to adjust and adapt our agenda and to develop new arguments without abandoning our ideals.

Since the creation of Culture Montréal in 2002, our activities in various areas — press releases, reports, speeches, the organization of local and international conferences, print and electronic

publications, and initiatives like the research-action with Richard Florida in 2004[64] — have increased.

But political involvement and proactive communication were only the most visible part of what we did. We were developing the roots and groundwork for the organization. Thanks to the commitment of its members, who came together in working committees that were backed by a small secretariat, Culture Montréal criss-crossed the boroughs of the city to discover, support, and make known the most promising initiatives. We participated in creating a cultural policy for the school boards of Montreal. We were invited to pedagogical days at neighbourhood schools to talk to teachers and school administrators about cultural projects. In 2003 we were called on to support the work of the Community Economic Development Corporations (CEDC), the funding of which was threatened. The following year, we took part in the struggle to prevent a music program from closing in the secondary schools. We also became involved in the movement to prevent the relocation of artists' workshops in one of the old industrial buildings that developers wanted to transform into condominiums. We became interested in real estate projects that were being developed throughout the island of Montreal so we could help improve their use of integrated cultural development.[65]

Culture Montréal learned to combine this outreach work with involvement in public debate and an active presence on the political scene.

Adopting a Cultural Development Policy without the Means Required

In the summer of 2005, Montreal finally adopted its first cultural development policy, the outcome of a long process involving

both the cultural and socio-economic communities. Public consultations allowed citizens to express their views and to contribute to the process.

Preparing this policy motivated members of Culture Montréal from the beginning of this process to the very end. It became the main subject of our actions for three months. We had clearly announced our colours and taken on these commitments in the days following the Montreal Summit.

Indeed, in a letter to the editor that appeared on September 3, 2002 in *Le Devoir* under the heading "Montreal Needs Leadership," I stated:

The process for creating and implementing cultural policy is just as important as its content, so that it does not become nothing more than a declaration of good intentions fed to artists and citizens concerned with culture. The more extensive the consultation is before we finalize it, the better the chances are of grounding the policy in reality and creating support from sectors not yet interested in cultural development. It is essential that this exercise be democratic, not bureaucratic. A citizen-centred approach must prevail at every stage. Elected officials must be present and committed, public servants and experts engaged, artists and their associations consulted, but we must not lose sight of the importance of civil society and the direct participation of citizens.

We also need to be cautious of utilitarianism and lobbying that would split cultural policy, thereby reducing it to nothing more than a statement of its desired consequences. The Service de la culture needs to be reinforced and the Conseil des arts has to be equipped with the means required

by its mission statement. Conditions for arts and culture creation and dissemination have to be improved. If this means promoting tourism and attracting foreign investments, so be it. But the final aim of cultural policy, to create a fulfilling environment for all city dwellers, must never fall from sight.

We had to react publicly again a few months later, in November 2002. In another editorial I wrote:

Cultural communities are still waiting for action from the city. While the Montreal Summit was an opportunity for unprecedented public affirmation of the role of the arts and culture as a fundamental vehicle in the city's development, and despite media attention and strategic alliances that arose among the cultural delegations, the days following this much-needed exercise have been quite difficult. Indeed, what we hear of the deliberations at the highest levels of city hall is hardly reassuring. The city says it has no money, arbitrations between the city's central functions and the boroughs are painful, negotiations to conclude the city's large contracts are being conducted in an atmosphere of fiscal anorexia, and the federal government has not yet responded to the need for several projects with cultural implications broached at the Montreal Summit. In this context, we imagine it was easy to justify delaying actual decisions fostering true cultural development.

The conclusion of this editorial could not have been any clearer: "If artists and their organizations are turned away again by this

city that owes a large part of its reputation and quality of life to them, we will all miss out."

One of the key transitions leading to the adoption of cultural policy was the submission, in June 2003, of a cultural policy statement by a consulting group chaired on a volunteer basis by consultant Raymond Bachand. Incidentally, sometimes fate is a great provider: the same Raymond Bachand, a few years later, became the provincial government's minister responsible for the Montreal region and as such participated in preparing *Montréal, Cultural Metropolis* in 2007, which I will discuss later.

The result of the work carried out by the consultancy group yielded impressive results. It allowed people to anticipate what path Montreal should take in the era of globalization and with the emergence of knowledge- and skills-based economies. They also identified five priorities: consolidation of public libraries, independence and funding of the Conseil des arts, urban beautification, synergy of the city with the cultural communities, and an internal municipal organization that would align all cultural initiatives. It also gave an idea of the magnitude of financial means required to achieve this. This statement helped reactivate the debates and consultations that preceded the adoption of the cultural policy.

The cultural development policy adopted in 2005 placed Montreal among the leading cultural cities planet-wide, philo-sophically. The major principles of access to culture, valuing heritage and design, supporting creation, and intercultural harmony were proclaimed loud and in flowing language. They were stated clearly and intelligently. The action plans selected were in keeping with the policy's intentions. The policy document was

also presented well; the graphics and photos pay homage to the creative genius of Montrealers.

The perspectives for implementing the policy were more modest. The policy was not accompanied by financial investments and commitments for additional spending. No increase for the Conseil des arts de Montréal was foreseen. City Hall only committed to seek assistance more zealously from higher levels of government.

Were we condemned to be a cultural metropolis on recycled paper only? The question was on everyone's lips in the cultural community and even beyond.

City Hall was penniless and increasingly battered. Montreal sagged beneath the weight of administrative structures that a quickly implemented demerger had just increased. Less than a year after the demergers, the fate of plans, policies, and tools that the metropolis had just taken on to respond to civil society's demands was uncertain, to say the least. What would become of the Montreal charter of rights and responsibilities, then ready to be adopted; of the new heritage policies and the Montreal Public Consultation Office; and the economic development strategies created in the wake of the 2002 summit?

On the regional level, the metropolitan dynamics rarely managed to get beyond the endless consultations, reports, branding strategies, and declarations with grandiose intentions. In Quebec, decentralization remained limited.

In 2005 we were far from the enthusiasm that reigned at the closing of the Montreal Summit three years earlier. Editorialists and certain economic leaders began to decry Montreal's continuing failure to act. Once again, the cultural metropolis

was wracked by doubt about its future. The musicians of the Orchestre symphonique went on strike. Teachers unions had just announced another boycott of school cultural outings: a pressure tactic to move their collective negotiations forward. Attempts — more or less improvised — to save the Montreal World Film Festival from a long-expected collapse made headlines, and did not augur well.

The municipal elections were to be held in barely a few months. Mayor Tremblay wanted to run, promising to not increase taxes. This was not a time for big ambition or great promises. The election campaign focused on cleanliness and eliminating the potholes inevitably left by Montreal winters.

The 2005 Municipal Election: Rising above Potholes

During the summer of 2005, Culture Montréal actively paved the way for its presence in the autumn elections. We hired a new executive director, Anne-Marie Jean. She had learned the ropes in the political offices in Ottawa with Isabelle Hudon, the new CEO of the Board of Trade of Metropolitan Montreal. Anne-Marie knew the players on the political scene very well and was familiar with the media. Culture Montréal then had six hundred members. Its program had been enriched when work was done prior to adopting the cultural policy. Its alliances with the city's driving forces were numerous and varied. They had been tested in action on several occasions.

On October 10, 2005, we published a ten-point program for the Montreal election and asked candidates to react. It contained the following proposals:

1. Fully and immediately implement the Cultural Development Policy and the Heritage Policy adopted by the City of Montreal in 2005;
2. Invest in artistic creativity by adequately funding the Conseil des arts de Montréal;
3. Improve Montreal's cultural infrastructures;
4. Develop the land and the built heritage of the city with respect, intelligence and vision;
5. Place multiculturalism at the heart of urban life;
6. Value new and emerging artists;
7. Democratize access to the arts and culture even more;
8. Take into account the contribution of the arts and culture in the economic and social development of the city and each of the boroughs;
9. Fully integrate the arts and culture in the strategies for metropolitan development;
10. Organize a summit entitled *Montréal, Cultural Metropolis* in 2007.

We included the tenth proposal because we were convinced it would be absolutely necessary to have an extraordinary initiative for governments to become more interested in the cultural metropolis's development. All the international examples confirmed that no city could attain the status of cultural metropolis without massive government support.

To ensure our proposals did not go unheeded, we brought the mayoralty candidates together in a public debate on cultural issues. Negotiations were arduous. We persisted, as cultural issues had been completely ignored so far and the campaign was ending in three weeks. Tired of resisting, the political organizers acceded

to our request, but the meeting had to be held at the crack of dawn.

On November 2, at 7:30 a.m., more than two hundred people and a host of journalists met over morning coffee at Théâtre Corona in the southwest of Montreal for the only public meeting in course of the campaign that would bring together the mayoralty candidates for a debate on cultural issues. The three candidates for mayor reacted to the proposals submitted by Culture Montréal. Each candidate had his or her priorities, but all committed to organizing *Montréal, Cultural Metropolis* in 2007 if they were elected to office.

On November 7, 2005, Gérald Tremblay was re-elected for a second term as Mayor of Montreal with 53 per cent of the vote. His party also won the mayoralty race in fourteen boroughs.

A Date with Destiny

As of early 2006, Culture Montréal was ready to ensure the newly re-elected mayor followed through on his commitment to organize a summit to provide Montreal with a cultural policy. Being a man of his word, he had no intention of shirking his duty. His first mandate had also convinced him to grant priority to issues of cultural development, even if he repeated ad infinitum that the city's financial situation prevented it from allocating the resources desired.

At Culture Montréal, it seemed obvious to us we would not move forward if we did not find a way to mobilize, empower, and involve all the forces likely to give the metropolis back its momentum. Governments and the business sector had to be stakeholders in the process from the start if we wanted them to

be at the finish line. Finding ourselves at the summit face-to-face with the City of Montreal was out-of-the-question. The disappointment felt following the adoption of a first cultural policy without an ambitious plan or precise budget still hung heavily in the air.

Instead of asking the mayor to undertake the process, we decided to take charge ourselves. We felt that Montreal's civil society could involve levels of government more effectively than a mayor, who, in every respect, would be placed in the position of begging.

A Dynamic Duo

Relying on City Hall's *de facto* commitment, I contacted the influential CEO of the Montreal metropolitan Board of Trade, Isabelle Hudon, who was not afraid to act. She was head of an open and respected organization with which we had collaborated closely since the foundation of Culture Montréal. She had direct access to the highest levels of government in Quebec City and in Ottawa, while Culture Montréal had more contact with the ministers and the senior civil servants in culture. I wanted to ensure Isabelle Hudon's strategic support, and her personal participation in the process. She agreed straightaway. And she did not do things halfway. She insisted on the importance of de-culturalizing (her own expression) the issue of developing the cultural metropolis. She argued that support for the arts and culture should not be reduced to its sectoral or special interest focus, but be understood as a *sine qua non* condition of fulfilling Montreal's full economic and social potential. Of course, this approach was much like the one Culture Montréal had been advocating since its creation. We forged an alliance that would be

key in the success of an intensive campaign lasting over almost two years.

The CEO of the Montreal Metropolitan Board of Trade and the President of Culture Montréal came together to jointly demand that the Quebec and Canadian governments act on the basis that culture can and must be a factor in the metropolis's development. We worked in tandem to converse with politicians and win over the business community.

First we made contact with the ministers responsible for the Montreal region at the provincial and federal levels. For the Government of Quebec this was Minister Line Beauchamp, also Minister of Culture and Communications. At the federal level, the new minister was Michael Fortier. Aware of the weight of government machinery and possible friction in terms of areas of responsibilities, we proposed an informal, friendly way of working. We suggested setting up a steering committee which would bring together five entities: the city, the two governments, the Montreal Metropolitan Board of Trade, and Culture Montréal. They agreed. In addition, the mayor was determined to use all his political weight to allocate all necessary resources from his administration for the enterprise to be successful.

A Made-to Measure Process

The first meeting of the steering committee was held on the morning of May 29, 2006 at City Hall. We were in the Peter-McGill room, where the executive committee usually met. The configuration of this rather austere but intimate room was ideal: it had a round table and there was space at the back for observers. The few operating rules suggested for the steering committee, of which I was chair, were simple and unanimously

accepted. They allowed us to establish rapidly a climate of confidence and co-operation, dedicated to seeking solutions. The first rule was that each of the five large partners would always be represented by the person who was seated around the table that morning, in this case Mayor Tremblay, ministers Beauchamp and Fortier, Isabelle Hudon, and me.

The initial makeup of the steering committee would be modified over the course of the eighteen months leading up to the summit. This would be the case following the Quebec election of 2007 when the new minister responsible for Montreal, Raymond Bachand, and the new Minister of Culture, Christine St-Pierre, replaced Lise Beauchamp, who took on other ministerial responsibilities. But what was absolutely remarkable — and to my knowledge, unique — was that all steering committee meetings were held in with the attendance of all its members. The atmosphere was sometimes tense, but always respectful and fairly informal. Needless to say, the process for choosing dates for our meetings was complicated. But the participants' personal commitment, not only that of the authorities they represented, was a decisive factor throughout the preparation of the summit, renamed *Rendez-vous novembre 2007 — Montréal, Cultural Metropolis*.

Of course, at each meeting the ministers and the mayor were accompanied by their senior civil servants. Approximately twenty attended each time. It was out of the question to progress in a discussion without having recourse to their knowledge and expertise. The strategic exchanges, however, took place around the central table among the steering committee's five official members. There was a free and unrestrained dynamic of sharing of intentions and political will. When consensus was reached on

various agenda items, these decisions made their way to the three administrations.

Throughout preparation of the *Rendez-vous*, the steering committee relied on a follow-up committee to prepare the meetings and implement its recommendations. Anne- Marie Jean, executive director of Culture Montréal, chaired this committee and each partner delegated a representative. More than one hundred civil servants from the three administrations helped develop the basis for an action plan spread over ten years, up until 2017. Several thematic working groups were also established, and representatives from the three arts councils were invited — those of Montreal, Quebec City, and Canada — and experts in finance, taxation, governance, and land-use planning.

It was decided, however, not to resume the extended consultations with cultural communities, except in case of large investment projects. We took it for granted that the eighteen months of intense and systematic consultation preceding adoption of the cultural policy less than a year before, and the obvious consensus on the contents of the policy, more than sufficed to develop the action plan. Besides, the organizations that had projects would be able to see them through by addressing Culture Montréal and the other partners, and did so.

On December 6, 2006, after seven months of work far from the spotlight, the steering committee made public its existence and its agenda. The City of Montreal, and the governments of Quebec and Canada, the Montreal Metropolitan Chamber of Commerce, and Culture Montréal jointly announced they were the five major partners in *Rendez-vous novembre 2007 — Montréal, Cultural Metropolis.*

The press release for the occasion spoke of "an event designed to consolidate the vision of Montreal as twenty-first century cultural metropolis that relied on creativity, originality, accessibility, and diversity, and to act on this vision." The press release also specified that "this vision, shared by the various driving forces of Montreal's artistic, cultural, economic, social, and democratic development, is notably expressed in the City of Montreal's Cultural Development Policy adopted in 2005 following three years of discussion and public consultations carried out with the people of Montreal."

At the same time, it was announced that *Rendez-vous novembre 2007* would implement the strategic measures and projects brought together in a ten-year action plan developed according to five major principles: democratization of access to the arts and culture; investment in the arts and culture; cultural quality of the environment; Montreal's cultural influence, and the necessary means to carry out the action plan.

Civil Society and the Political Class Meet

Eleven months later, many Montrealers converged upon the Palais des congrès to participate in *Rendez-vous*.

More than thirteen hundred people registered. They were artists, cultural entrepreneurs, creators in all areas, urban planners, community activists, educators, academics and a significant contingent of leaders of companies and private foundations. They were not used to meeting on a daily basis, but all had the same desire to be involved. The watchword circulating for months was clear: all speakers must announce in their specific commitment to contribute to the construction of the cultural metropolis. This was not the time for never-ending discussions, but for action.

Many elected officials of all political backgrounds represented at the Quebec National Assembly, the Parliament of Canada, and Montreal's City Hall were also present. The premier of Quebec and ministers of his government made announcements on new programs and investments in infrastructure. The federal government also announced its participation in infrastructure projects, as did the City of Montreal. The most important joint announcement, financially speaking, was that of creating a Quartier des spectacles, to which Quebec City, Ottawa, and Montreal committed to devote $140 million. The municipal and provincial governments also announced $37.5 million over three years to consolidate Montreal's network of public libraries. The Board of Trade and representatives from the private sector also made commitments that may be found in the action plan.[66] Culture Montréal did the same.

For two days, the participants at *Rendez-vous* enjoyed the attention of several ministers and the mayor of Montreal, none of whom left the table of the central plenary meeting. The deliberations were followed by members of political offices, deputy ministers, senior civil servants, and leaders of the three arts councils, as well as by all the organizations financing the arts and culture. For all participants, including those from the cultural community, it was an opportunity for an accelerated, intensive course on the complex problems of cultural development in the metropolis. Leaders of the Jazz Festival, Just for Laughs, and the World Film Festival enjoyed the same amount of speaking time as emerging artists or as Anik Bissonnette, Montreal's most famous ballerina, who spoke on behalf of the dance world. The leaders of L'Oréal or Rio Tinto Alcan didn't speak any longer than the spokesperson for the coalition Pour des quartiers culturels à

Montréal (For Cultural Neighbourhoods in Montreal). Throughout the event, interventions at the central table, informal meetings on the grande place of *Rendez-vous*, the press conference, the presentations of cultural organizations in the eighty information booths, the festive and friendly moments and solemn speeches allowed us to build consensus on an action plan and to accumulate tangible commitments to implement them.

Over and above major investments, indexed or increased subsidies, programs announced for emerging artists, agreements concluded at the last minute on old and new projects, this gathering allowed people to clearly express a collective will to forego the defeatism and cynicism that had again threatened the metropolis if nothing were done.

The two most common syndromes at this type of event were avoided; neither magical thinking nor complaining were much in evidence at the *Rendez-vous*.

We knew immediately that *Rendez-vous novembre 2007 — Montréal, Cultural Metropolis* would have a lasting effect. Approximately one hundred accredited journalists, editorialists, columnists, and reporters of the written and electronic media covered and commented on the event. As I write these lines, I see that people are still interested in what we call the "follow-up to the *Rendez-vous*." Not a week goes by that elected officials, heads of companies, or leaders do not mention the Action Plan to be implemented, emphasize or call for progress in the direction sought. We are organizing a steering committee for the 2007–2017 Action Plan and entrusting the follow-up to a permanent secretariat.

Some Lessons for the Future

Now that the dust has somewhat settled and the results of the *Rendez-vous* have begun to take shape, it seems useful to me to try to draw some lessons from Culture Montréal's intense activity so that this mobilization initiative can help build the cultural metropolis.

We need to take stock, in order to avoid starting over each time cultural development issues must be brought to the forefront. Taking stock is also a way to share the experience acquired with other individuals and groups seeking similar objectives. This last consideration affects me as I realize how difficult it was to access concrete descriptions of the transformation processes and demonstrations of leadership that took place in other cities, the cultural development of which inspired us.

Here are the five lessons I learned from what we accomplished between the November 2005 municipal election campaign and the close of *Rendez-vous Montréal, Cultural Metropolis* on November 13, 2007. I sum them up in the form of recommendations with comments.

1. **Content First**. We would not have been able to attain the results of the *Rendez-vous* without the patient and methodical work of developing, sharing, and widely adopting Montreal's cultural policies. Developing a common vocabulary, clarifying basic concepts, and remaining open to contributions from all participants is essential for winning people over. There is no point in action without vision and content.
2. **Consensus Building**. The targeted consultations of the consulting group chaired by Raymond Bachand and the

extended consultation of the Montreal Public Consultation Office allowed for general consensus to be reached in favour of a cultural metropolis within the communities immediately concerned and, more generally, in Montreal civic society. Culture Montréal, which contributed continuously to all these consultations, had the legitimacy desired to propose holding a summit that would focus on an action plan.

3. **Properly Analysing Economic Circumstances and Evaluating the Driving Forces**. Culture Montréal proposed organizing the summit on cultural development by entering an undistinguished municipal election campaign. We saw growing impatience for a new civic leadership emerging in Montreal. We experienced this in our own ranks, and perceived it in other communities. A few artists and cultural entrepreneurs also expressed this publicly, notably those who were trying to advance projects that weren't managing to take off, such as the Quartier des spectacles. The new CEO of the Board of Trade, Isabelle Hudon, spiritedly demonstrated similar impatience with the city's economic communities. Sharing awareness of the urgency of acting together to re-energize the metropolis allowed us to consolidate effective civic leadership. By proposing action instead of joining in the general complaints about the city's situation, we created a catalyzing effect.

4. **Relying on the Support of Social Networks**. Society's collective ability to influence the course of events in a big city depends far less than it seems on official collaboration proceedings or on the arbitration by elected officials at city hall. This force results from adding networks of people and institutions that become decisive in achieving a shared vision and agreed-upon objectives. The reconciliation work and collaboration with

business and community-based environments undertaken by Culture Montréal from the time of its creation, in 2002, was crystallized by the perspective of the *Rendez-vous*. We increased tenfold the approaches and arguments in favour of the cultural metropolis, along with direct access to economic and political decision-makers.

5. **Eradicate Cynicism in Relationships with Elected Officials**. The intense dynamic of co-operation that gradually took hold between leaders of civic society and elected officials implied unequivocal recognition of their responsibilities and accomplishments. Politicians, men and women, were in a very different position than I or the CEO of a chamber of commerce. This needed to be recognized, understood, and respected. We must also properly acknowledge their decisions that advance things for the community. Failure to do so on the pretext that this is the work we expect from politicians is not only bad judgment, but also a way of discrediting elective democracy.

The quality of the relationships with the members of the public service is also a success factor in this type of large-scale mobilization. The November 2007 *Rendez-vous* was also in very large part the result of the work accomplished by the cultural public servants of the municipal, provincial, and federal governments that were also supported, in the home stretch, by their colleagues from their colleagues in other ministries and departments.

Democratizing by Mobilizing Citizens
Culture Montréal had no other choice but to keep its eyes peeled on the follow-up of *Rendez-vous*.

I was convinced that the safest way of keeping the momentum

we had achieved involved a conscious effort to raise awareness among citizens themselves and to mobilize them. Of course, we had to continue working in the meeting rooms and halls of government. That was a way to move things forward. But if people on the street did not hear about our work and were not interested in it, it would be hard to offset any technocratic excesses and attempts to take advantage of our momentum. The way to develop a liveable and lasting cultural metropolis is not by proceeding from top to bottom; it involves setting aside creative and other tensions between the experts, elected officials, and citizens.

Governance and Cultural Leadership: Failures and Starting Over

It is difficult, without bureaucratizing, to implement lasting and effective policies and initiatives that demand fully developing the arts and culture in a city such as Montreal. To my knowledge, few cities in the world have managed to do this. Yet that is what Culture Montréal was proposing to do when, on February 23, 2007, it published a leaflet for the creation of Agence montréalaise de développement des arts et de la culture (the Montreal Agency for the Development of the Arts and Culture).

Culture Montréal proposed nothing less than a complete overhaul of Montreal's cultural governance at the municipal level. Noting the scarcity of available resources, the excess of structures, and the loss of centrality and expertise caused by decentralization to the boroughs, we suggested consolidating all the services and support for the arts and letters, heritage, big festivals, and cultural industries into one agency. We suggested making this agency responsible for research, planning, infrastructure, funding,

and all aspects of implementing cultural policy. We also recommended the agency be independent from city council, and thereby independent from undue political influence while having the power to act over a longer period than an electoral term.

Just after publication of Culture Montréal's proposal, the media brought forth a number of concepts, such as a Department of Montreal Culture. Initial reactions were positive: the idea of a clean sweep in the confusion of Montreal's administrative restructuring was always appealing at first.

But the idea of creating an agency also worried people. Elected officials and municipal public servants felt threatened and implied it was a clandestine way of privatizing or out-sourcing the municipal management of culture. In Quebec City and in other regions, people expressed the fear that Montreal's strategic weight would become decidedly predominant. But, above all, it was the Conseil des arts de Montréal itself and a number of organizations receiving subsidies that were worried. They feared the Conseil des arts would be put at a disadvantage and marginalized by a reconfiguration that would only make it a part of a larger whole, while our intention was to place support for the arts at the heart of the city's cultural development. Some people were especially anxious and became carried away. The gloves came off and the fisticuffs began. They imputed us with the most Machiavellian of intentions. The debate got off to a bad start.

Nevertheless, despite information sessions, press conferences, open letters, and meetings with the heads and administrators of the Conseil des arts, Culture Montréal could not allay fears in the artistic communities and shed light on the fundamental aspects of its proposal. Nothing worked: people were heated up and communication was poor.

Emerging from its strategic meetings of August 2007, Culture Montréal announced it was withdrawing its proposal of creating a Department of Montreal Culture and would no longer be part of *Rendez-vous Montréal, Cultural Metropolis*, which was to take place in barely two months. We concluded that the debate was contaminated by special interests and pursing it in such conditions risked deflecting attention from the *Rendez-vous*'s main objectives and action plan. The proposal was nipped in the bud. The debate on Montreal's cultural governance remained unfinished.

This difficult episode in the history of Culture Montréal allows us to better grasp the crucial importance of analyzing the circumstances, interests, and predispositions of all opposing parties before taking action. The discussion on cultural governance was very recent in Montreal and was just taking hold in a few large cities and regions of Europe and North America. We had acted in great haste by launching it this way prior to the *Rendez-vous*.

In the fall of 2008, Culture Montréal organized an international conference as part of the Entretiens Jacques-Cartier in Montreal. Called *La gouvernance culturelle des grandes villes: enjeux et possibilities* (*Cultural Governance of Big Cities: Issues and Possibilities*), the event allowed three hundred people to hear speakers from Quebec, Ontario, British Columbia, the United States, Belgium, Switzerland, France, Spain, and Holland reflect on the always complex dynamics between cultural stakeholders, political institutions, and citizens. It was a debate to be followed in Montreal and other cities.

But I was increasingly convinced that before we tackled new structures and modes of organization and governance, it was intelligence, ideas, initiatives, and individuals, backed by

institutions and organizations, that were of prime importance. The commitment of the people and leadership are at the foundation of any transformational movement. Successful leadership implies the alignment of three key elements: vision, credibility, and integrity. These would be most important in progressing toward real recognition of arts and culture for cities in the twenty-first century.

The issue of cultural leadership largely supplanted that of governance.

Montréal, Cultural Metropolis: Provisional Hypotheses

Is Montreal a cultural metropolis? The question is now often asked outside the cultural sector. Replies stream in from various communities and make their way to the editorial pages of the city's newspapers. They also strike a chord in the speeches of politicians at all levels of government. The question also interests both the specialists and neophytes of urban branding, who forge ahead with their sometimes contradictory but interesting recommendations. It is the object of theses in universities and at international conferences. Taxi drivers are also beginning to comment on it, a sure sign that from now on this issue will be part of daily discussions on Montreal's future.

I have no definitive response to this question and am not looking for one. The name *Montréal, Cultural Metropolis* has become a convenient and widespread way of designating a collective project that calls upon the arts and culture to rethink the way of life in the city, build it, and present it to the world. The concept of a cultural metropolis, Montreal-style, does not bank solely on large projects, downtown, or large-scale festival offerings, but is conveyed by hundreds of institutional and individual initiatives

and the blossoming of a far richer cultural life in the boroughs. This richer cultural life requires artists and cultural professionals to be active and vigilant; it must also be supported by teachers in the schools and by cultural participation in the arts by amateurs as a form of cultural recreation.

By associating the word *cultural* with *metropolis*, we are indicating a clear bias and also establishing a relationship of inspiration and emulation with a series of cities with strong cultural communities, such as Barcelona, Berlin, Lyon, and others. By emphasizing characteristics specific to cities and metropolitan regions, we are encouraging people to recognize large urban issues that required extensive reconfiguration of cultural programming and participation.

No one can claim authoritatively that Montreal is or is not a cultural metropolis because the concept is too vague and too fluid. But it matters little, as it is a dynamic concept and an inspiring objective increasingly shared in the city. There is certainly a brand strategy to be developed to convey this large urban project to the rest of the world. We must ensure that the choice of a specific angle and a simple and attention-grabbing formula is not done based on the projects and interests of a few entrepreneurs, but that conveys and projects the artistic and cultural energy, vitality, and friendliness of a different, inimitable metropolis.

Montreal must find its own way, one that will be feasible in the long run. The city must be the cultural metropolis that its artists, intellectuals, cultural entrepreneurs, private sector, elected officials, and, above all, its population want and will build together.

The main part of the work will always be spontaneous, unpredictable, anarchic, disorganized, fragmented, and surprising like life itself. That is the uncontrolled and irresistible energy that

fascinates and delights us when we visit the most inspiring cultural metropolises. But it is also the specific and genuine mix of geography, climate, history, the intrinsic genius of the place and the architecture, the organization of the streets and squares, and what is offered by cultural institutions that attracts us and invites us to return to these cities.

Some of the work of developing a cultural metropolis must, of course, be planned and carried out in cycles that will vary in length. The question is to know how, by whom, and for whom? As I emphasized in the introduction, I am convinced that cultural development is too important for us to leave in the hands of just the cultural sector, business people, politicians, and public servants who don't constantly interact with one another and with the population in terms of public consultations and democratic elections.

This conviction led me to participate in the creation and development of Culture Montréal. Culture Montréal is a typically Montreal invention. We took our inspiration from organizations such as Héritage Montréal and socio-political movements at work in several other cities. We invented our own model, which is still at its beginnings, but the first results are encouraging.

We are going to pursue our course of action, clarifying from time to time our goals in order to assess our progress.

ART AND CULTURE CANNOT SAVE THE WORLD BUT CAN HELP CHANGE IT

The curtain has fallen on the first decade of the twenty-first century. It fell slowly, protesting. It would be difficult to claim that the state of our world was not a source of concern and disillusionment.

The financial crisis of 2008 that led to the worldwide recession in 2009, the epicentre of which was in our immediate neighbour to the south, had a domino effect. No one can yet assess how long it will last or all its consequences. Globalization — which has realigned relations between countries, changed the rules of the game, and redefined many aspects of our lives, including our cultures — has happened so quickly that economists such as Jeff Rubin[67] have gone so far as to predict its imminent end.

For the moment, we are seeing a return toward strong national governments. Protectionist policies are growing stronger, but have been denounced on all sides because national economies still

depend strongly on one another. In 2009, most rich countries desperately tried, with varying degrees of success, to shield themselves from a generalized disaster by improvising more-or-less sophisticated recovery plans. But the poorest and most vulnerable segments of their populations have not been spared. While the wealthiest people were able to take advantage of bargains, the poorest saw their purchasing power and futures shrink radically.

Environmentally speaking, scientists and ecological activists repeatedly sounded the alarm, noting the acceleration of global warming. Their apocalyptic predictions of melting glaciers in the Arctic, or striking images of mountain peaks in the Appalachians being decapitated to mine fossil fuel, resonated among the youth and a growing portion of the world's population. Awareness is growing that we are all living on time borrowed from the future of life on earth. But political leaders constantly postpone the payback deadline for fear of becoming scapegoats of their electorate affected by the draconian changes that would be necessary.

Various attempts to reach international political action to get the world's economy back on track and to offset the deterioration of the environment were not successful. We saw this again at the G8 Summit, which took place in July 2009, close to the ruins left by a violent earthquake that struck the city of Aquila, Italy. The results were very slight, according to all experts. The first presence of President Obama at this forum of countries that represent only 15 per cent of the world's population, but 60 per cent of its economic wealth, brought hopes that were dashed; thus, members of the G8 agreed to reduce by half air pollution emissions by 2050, in four decades' time. They could not agree on recovery plans. Certain countries pleaded for a rapid return to budgetary balances, while the United States contemplated the likelihood of a deficit just

shy of $2 trillion by the end of the summer. In the hallways of the G8 Summit, people talked about the work of teams of public servants constructing models for the reduction of public spending when the economy begins to improve. This was, needless to say, a worrisome perspective for education and culture.

Poor countries, where 80 per cent of the world's population lives, will likely wait a long time before any form of redistribution of wealth begins. Their citizens strive to survive the ravages caused by epidemics, lack of drinking water, and famine. Horror, desolation, and death hit in early 2010 when an earthquake struck Haiti. Thirty-two countries are now experiencing a serious shortage of food. Close to one billion human beings are suffering from malnutrition. Moreover, there are approximately thirty active war zones. They are the theatre of extreme violence and most abject barbarity into which the human race can sink.

Let us be clear: arts and culture cannot by themselves constitute a valid response to all these problems. Nor can education, science, or even money be the universal solution to these ills. Religions, whichever they may be, will not solve them either.

The issues confronting civilization as we know it have become so numerous and complex that we have the feeling we cannot escape them. Yet even if some of them can only worsen with the passage of time, such as pollution, most of these problems are not new in the history of humanity. We are managing today to resolve a more significant share of them than one hundred years ago. Everything is not so black; we are making progress.

But having the technological means, and above all, the illusion of our ability to observe events almost anywhere in the world in real time has dire ethical consequences. The possibility of being informed instantaneously of the stumbling of our society and of

natural catastrophes does not give us the means to analyze what is going on or to project us into the future. In such conditions, indifference and fatalism will begin to gain ground.

Some people choose intentional ignorance the better to live their lives; this is their right. But many others engage and take action to attempt to change the course of events and to shape a better future. The hard times we are experiencing generate wonderful acts of generosity, compassion, and support that make the front pages of newspapers less often than the atrocities of the effects they try to offset. Each attack, war, humanitarian disaster, or catastrophic accident gives rise to heroic gestures by men and women who had no predisposition for this type of behaviour before the misfortune rained down on their world and led them to help others. The intense reaction of solidarity in many forms that followed the earthquake in Haiti reminds us of that. Furthermore, aside from moments of extreme crisis, the will to improve the fate of one's fellow human beings is evidenced by the increase of volunteer work and donations from people of all walks of life.[68]

This is the light that shines from the refusal to give in, underlies daily gestures of solidarity, and gives people courage to not turn away from the disturbing sight of our world.

Changing the World

If it is true that the great majority of human beings are still battling problems of survival, that in no way eliminates their need to be exposed to or participate in artistic creation and culture. Stories, songs, poems, music, dance, drawing, and other forms of artistic creation and cultural events are evident in refugee camps

and afflicted communities are the proof that we cannot live without a minimum of cultural expression. We saw this phenomenon in the Nazi concentration camps, we observe it in the camps of Palestinian refugees, and it was seen when the apartheid regime fell in South Africa and the Mandela government encouraged the exhibition of works created during the time when extreme racism reigned.

Of course, many of the creations that arise out of chaos and human misery may disappear without a trace, but they may also survive, to become part of the culture and history of a people, of a continent, or even of world heritage. As Jane Jacobs wrote in *Dark Age Ahead*, after commenting on the situation in Ireland and reminding us of the importance of songs, "Every Irish song is a song of protest."[69] And as a means of transmitting culture, "The emotional powers of the arts authentic arts, not official propaganda — are obviously central to every culture."[70]

Where people struggle for survival, the arts and culture play a role. The question is to know if we can improve these lives, even if threatened with destruction, by increasing the share of the public purse granted to the arts and culture. I am convinced the answer is yes.

Art and Culture as Vehicles of Civilization

Art and culture pave the way for civilization in all dimensions and at all levels, from the most modest and local to the most extravagant and global. They are in a way guarantors of an aspiration to civilization. They demand and proclaim it loud and clear. They cannot, of course, resolve evil, but their presence is necessary to give us the means to express to others what we feel and dream, and what connects us to life.

Art's intrinsic power to transform affects all people. It is not uncommon to hear such testimony from people who have a more or less developed artistic practice, as I mention in part two of this book. Even people who have a more contemplative relationship with artistic works and expressions describe the spiritual and behavioural transformations they experience.

The arts and culture also have the power to transform our environment. We are all capable of quoting examples to illustrate this phenomenon, especially as it has become the goal of various strategies of all levels of government.

Democratizing access to the arts and the will to assert national identities have justified for more than six decades the investments in and the measures taken that encouraged the development of a dynamic cultural sector in a large number of countries. Today, this sector of activity is called upon to play a very significant economic and social role, including at the level of cities and regions. This poses significant challenges in terms of individual institutional stakeholders, whether they are connected to the more classic stream of subsidized arts or if involved in the cultural industries, because they are not yet equipped to play that role. It also requires adjustments by governments, regulatory organizations, and funding structures that can no longer be content to somehow respond to the wishes of the cultural sector by ignoring civil society and citizens.

Cultural Participation as a Vision for Change

Access to the arts and culture for all is a vision for change. Cultural participation, in all its forms, from now on has become a goal to strive for, so that big cities don't fall apart due to economic, social, linguistic, and cultural disparities. By investing more in cul-

tural participation, public art, artistic productions, and artistic and cultural programs in schools, we can only improve creativity, free thinking, and citizens' ability to live together.

Cultural democratization and participation may also be the goal of a promising and lasting pact between the cultural sector and the population, but it must be supported financially by government, which does not mean they should seek to regulate it.

We must also protect artists' freedoms while valuing their contributions to society and paying them better for their work. We must not lose sight that if governments and arts councils are the first entities responsible for protecting art and artists, the protection will be that much stronger and effective if it is required by the citizens themselves and the leaders and organizations of civil society. That will be one of the consequences of the pact between the cultural sector and the population I have just described.

Call For Debate and To Action

As I wrote in the introduction, I am well aware that some people do not share my views. They would like to qualify them or contest them. I invite them to do so. It may be I have not paid justice to people who played a role in some of the events I have described. I apologize and beg their indulgence.

I would like this book to enrich public discussion on the choices we will have to make, both those concerning the future of the cultural sector as well as those related to the architecture of cultural development on the municipal, regional, and national levels.

Moreover, I wish to specify that if my experience is grounded in a big city, it does not lead me to discredit the dynamics specific

to rural areas or smaller communities. On the contrary, I think that we often seek to reproduce in large cities the same human relationships and cultural models that are created more spontaneously in smaller communities.

Finally, I would like this book to be read as a call for action and citizen participation. While we must think and discuss, we must also take action. The state of our world demands it. We cannot content ourselves to observe elected political officials hold forth and act on our behalf. There will be no significant advances for world peace, the protection of the environment, the struggle against poverty, or the promotion of human rights, including cultural rights, if we do not all do our share. We must make our voices heard and plunge into the fray, try to promote the changes we believe are essential. In doing so, we will meet ordinary people who, collectively, can do extraordinary things.

A profound shift for locally including the arts and culture in our way of life in society is underway. We see demonstrations of it around the planet. Art's power to transform and enchant is gaining ground. Everything encourages us in that direction. It is a task we can achieve. Culture is the future.

Concluding Remarks

While I was finishing this book, a long-time friend staying in Madrid sent me an email in which she said she had seen, at the Reina Sofia National Museum and Art Centre, Picasso's painting *Guernica*[71] and a model of the Spanish Republican Pavilion at the 1937 World's Fair in Paris in which it had been exhibited.

On a wall of this pavilion was a sentence she had copied and sent me saying I might find it useful.

Dear reader, I offer you this sentence in turn:

"Culture is only worthy of this name inasmuch as it is for all mankind."

NOTES

Introduction

1 The contract signed with Ex Machina to extend *Moulin à Images* until 2014 is for $22 million, while the one between Quebec City and Cirque du Soleil to present a custom-made show over five years created around the theme "The Dream Continues" totals $30 million.

2 More than four hundred exhibitions and shows were presented as part of the 2010 Cultural Olympiad.

3 In April 2009, parliamentary journalist Chantal Hébert pointed out in her blog (http://www2.lactualite.com/chantal-hebert) that since the reopening of Parliament in January, MPs had spoken more about culture than the environment in the House of Commons.

4 Richard Florida created an index of creative cities that are characterized by having a very educated population, a high percentage

of people in professions in the creative field, numerous immigrants, and a dynamic high technology sector.

5 See the site of the Universal Forum of Cultures Foundation: www.fundacioforum.org/city/download/eng/directrius.pdf.

Part One

6 A unanimous motion by Quebec's National Assembly to this effect was adopted on June 17, 1997.

7 Louise Beaudoin was Minister of Culture and Communications from August 3, 1995 to December 15, 1998.

8 The Bos Agency has designed each of the *Journées de la culture*'s annual campaigns since 1997. For an overview, consult http://www.culturepourtous.ca/journeesdelaculture/archives.htm.

9 In 2008, the *Journées de la culture* mobilized 2,200 organizers of events in 295 municipalities in Quebec and more than 350,000 citizens are estimated to have participated in them.

10 UNESCO, *Universal Declaration on Cultural Diversity*, Adopted by the 31st session of the UNESCO General Conference, Paris, November 2, 2001. This document may be consulted at: http://unesdoc.unesco.org/images/0012/001271/127160m.pdf.

11 Guy Rocher, *Introduction à la sociologie générale, vol. 1, L'action sociale*, Montréal, Hurtubise HMH, 1969, p. 88.

12 www.anndalyconsulting.com.

13 http://www.ci.austin.tx.us/culturalplan/plan.htm.

14 *Valuing Culture: Measuring and Understanding Canada's Creative Economy* was edited by Michael Bloom and may be downloaded at http://sso.conferenceboard.ca/document_summary.aspx.

15 Hill Strategies Research Inc., "Volunteers in Arts and Culture Organizations in Canada in 2004," *Statistical Insights on the*

Arts 5, 2, January 2007. Available at: http://www.hillstrategies. com/resources_details.php?resUID=1000207&lang=0.

16 In 2003, Ontario was a net importer and Quebec a net exporter of cultural products. Quebec exported more cultural goods ($738 million) than it imported ($398 million) in 2003. Ontario imported $3 billion worth of cultural products and exported almost $1.3 billion. Quebec, which was the second source and destination for cultural products exchanged in Canada, represented 10 per cent of imports and 30 per cent of exports in 2003. (Reference: Statistics Canada, *Economic Contribution of the Culture Sector to Canada's Provinces*, March 2007. Available at http:// www.statcan.gc.ca/pub/81-595-m/2006037/4053322-eng.htm.

17 In 2006–2007, the combined cultural expenses of the three levels of government reached $8.23 billion. See Statistics Canada, *Government Expenditures on Culture: Data Tables 2006/2007*. Available at http://www.statcan.gc.ca/pub/87f0001x/87f0001x2009001-eng. htm.

18 Hill Strategies Research Inc., "Consumer Spending on Culture in 2005 in Canada, the Provinces and 15 Metropolitan Areas," *Resources on the Arts 5*, 3, February 2007. Available at http://www. hillstrategies.com/resources_details.php?resUID=1000215&lang =0.

19 Claude Edgar Dalphond, *Le système culturel québécois en perspective*, Gouvernement du Québec, 2009, p. 60. Available at www.mcccf.gouv.qc.ca/index.php?id=20.

20 Statistics Canada, *Canadian Framework for Culture Statistics*, August 2004. Available at http://www.statcan.gc.ca/pub/81-595-m/ 81-595-m2004021-eng.pdf.

21 www.americansforthearts.org/information_services/research /services/economic_impact/005.asp.

22 Statistics Canada, *Government Expenses on Culture: Data Tables 2006/2007*. Available at www.statcan.gc.ca/pub/87f0001x/87 f0001x2009001-eng.htm.

23 *Provincial and territorial government operating grants, contributions and transfers for culture, by function and province or territory, 2006/2007*. Available at www.statcan.gc.ca/pub/87f0001x/2009 001/t008-eng.htm.

24 See: http://www.hillstrategies.com/index.php.

25 *Portrait socioéconomique des artistes au Québec*. Available at www.mcccf.gouv.qc.ca/index.php?id=2035.

26 In 2008, Cirque du Soleil paid out more than $35.4 million in residual rights. More than half this amount, 56 per cent, was paid to Quebec designers and 1 per cent to designers living elsewhere in Canada.

27 Pierre-Michel Menger, *Du labeur à l'œuvre. Portrait de l'artiste en travailleur*, Paris, Seuil, 2002.

28 http://www.mcccf.gouv.qc.ca/index.php?id=2035.

29 As an example, the National Theatre School of Canada accepts each year only 60 students selected from more than 1,100 applicants.

30 *Portrait socioéconomique des artistes au Québec*. Available at www.mcccf.gouv.qc.ca/index.php?id=2035.

31 For an overview of the chronology of events, please consult http://www.ccarts.ca/en/search/default.asp.

32 Instituted by the Prime Minister, Louis Saint-Laurent, the Commission was chaired by career diplomat Vincent Massey and had as its members Henri Lévesque, Arthur Surveyer, Norman Mackenzie, and Hilda Neatby. The commission held 114 public meetings throughout Canada and heard 1,200 witnesses. Its final report was submitted in June 1951. It inspired the founding of

the National Library of Canada, the Canada Council for the Arts, and the National Theatre School. This report, often designated as the Massey Report or the Massey Commission, is considered the "bible" from which numerous federal cultural initiatives in Canada were created. The Quebec government, fearing federal interventions in its areas of competence, refused to participate in the work of the Commission when it came though Montreal on November 26, 1949. We should also mention that the Duplessis regime was resistant to the most liberal ideas expressed by the Commissioners.

33 On page 20 of the report there is a revealing comment regarding the commissioners' point of view: "Every intelligent Canadian acknowledges his debt to the United States for excellent films, radio programmes and periodicals. But the price may be excessive." *Report of the Royal Commission on National Development in the Arts, Letters & Sciences in Canada 1949–1951*, consulted online at http://www.collectionscanada.gc.ca/massey/h5-407-e.html.

34 "Quite apart from the fact that the problems confronting us have little in common with those in other countries, we find that in general they are dealt with abroad by a centralized Ministry of National Education or by a Ministry of Cultural Affairs, arrangements which, of course, in Canada are constitutionally impossible or undesirable [...]."*Report of the Royal Commission on National Development in the Arts, Letters & Sciences in Canada 1949–1951*, p. 371, consulted online at http://www.collectionscanada.gc.ca/massey/h5-452-e.html.

35 On behalf of the American Secretary of State, George Marshall, this plan was intended to help reconstruct Europe after World War II. American products, including its cultural production, thus found considerable outlets.

36 Under the Carter administration, Congress required the National Endowment for the Arts (NEA) and government agencies to grant priority to American artistic creation and cultural diversity.

37 *Cool Britannia* was actually a branding strategy begun after Tony Blair was elected. It involved trying to change Great Britain's image by presenting it as young, modern, and hip, giving momentum to the new government. The most emblematic photo of the period is the one in which Noel Gallagher, of the rock group Oasis, is drinking champagne with Tony Blair at a party at 10 Downing Street in July 1997.

38 For an overview of these reviews, consult www.surlesarts.com/article_details.php?artUID=50250. See also Florida's response to his detractors: *La revanche des éteignoirs* (2004): http://www.culturemontreal.ca/pdf/050127_RevancheFlorida_fr.pdf.

39 The Coalition for Cultural Diversity, which brings together professional associations and organizations from Quebec and Canadian cultural communities, was created in 1999 and played a leading role in efforts leading to the adoption of the Convention on the Diversity of Cultural Expressions.

40 Quoted by Jack Ralite in *Culture toujours ... et plus que jamais!*, edited by Martine Aubry, Éditions de l'Aube, 2004, p. 92.

41 For example, a Quebec author-composer can easily be a member of seven different associations: l'Union des artistes, la Guilde des musiciens, la Société des auteurs de radio, télévision et cinéma (sartec), la Société des auteurs et compositeurs dramatiques (SACD), la Société du droit de reproduction des auteurs compositeurs et éditeurs au Canada (SODRAC), la Société canadienne des auteurs, compositeurs et éditeurs de musique (SOCAN) and the Société professionnelle des auteurs et des compositeurs du Québec (SPACQ).

Part Two

42 See: www.wolfbrown.com/images/articles/ValuesStudyReport Summary.pdf.

43 See: *Pour une nouvelle alliance entre les bibliothécaires et les autres professionnels de la culture* au www.culturemontreal.ca/positions/ 030522_braultbiblio.htm.

44 Surtitles were developed at the Canadian Opera Company by Gunta Dreifelds, Lotfi Mansouri, and John Leberg and used for the first time at a performance of *Electra* by Richard Strauss on January 21, 1983.

45 Jane Jacobs, *Dark Age Ahead*, New York, Random House, 2004, p. 116.

Part Three

46 Graduates of the National Theatre School of Canada are equally divided between the French- and English-speaking sections.

47 Max Wyman, *The Defiant Imagination: Why Culture Matters*, Vancouver/Toronto, Douglas & McIntyre, p. 41–47.

48 Sir Peter Hall, *Cities in Civilization: Culture, Innovation and Urban Order*, London, Weidenfeld & Nicholson, 1998.

49 The expression "Quiet Revolution" was invented by a journalist at *The Globe and Mail* shortly after Jean Lesage was elected in 1960. It designates the period between 1960 and 1970 during which people asserted the separation of Church and State, proclaimed the welfare state as a tool for development, and began a widespread modernization of Quebec.

50 Text of the manifesto is available at the artothèque and may be consulted at www.artotheque.ca.

51 Richard Florida, Louis Musante, and Kevin Stolarick, "Montreal's Capacity for Creative Connectivity: Outlook & Opportunities,"

Martin Prosperity Institute, 2009. A summary of this article is available at http://www.culturemontreal.ca/pdf/050127_cataly tix_eng.pdf.

52 Jean-Marc Larrue, *Le Monument inattendu. Le Monument-National, 1893–1993*, Montréal, Éditions Hurtubise HMH, 1993.

53 In 2004, a permanent exhibition entitled "*Monument-National: A Site of Great Undertakings*" was set up in a hallway adjacent to the Ludger-Duvernay Auditorium.

54 See the site of the Office of Public Consultation of Montreal to learn about realty projects of the SDA (Société de développement Angus) in the Quadrilatère Saint-Laurent: http://www2.ville .montreal.qc.ca/ldvdm/jsp/ocpm/ocpm.jsp?laPage=projet38.jsp.

55 The Du Maurier Theatre Centre in Toronto. This place changed names in 2003, like the Studio du Maurier of the Monument-National, due to the law forbidding tobacco-related sponsorships.

56 In 1992, the Montreal Board of Trade and the Chambre de commerce de Montréal merged to become one bilingual entity, the Board of Trade of Metropolitan Montreal.

57 Laurier Cloutier, "La Chambre veut stopper l'appauvrissement de Montréal," *La Presse*, Tuesday, September 14, 1993, p. C1.

58 Organized by the Fédération des femmes du Québec in collaboration with 150 community groups, this walk aimed to improve the economic conditions of women. For ten days, the marchers received significant support from the population. On June 4, 1995, after walking for 200 kilometres, close to they arrived in Quebec City to find 20,000 supporters awaiting them. The Quebec government responded positively to certain of their demands, but mainly this initiative allowed the community sector to become known and gave it credibility.

59 In 1992, Cirque du Soleil visited Tokyo, followed by seven other

Japanese cities. The following year, it travelled to sixty cities in Switzerland with Cirque Knie, and then went off to conquer Las Vegas.

60 Lucien Bouchard was Premier of Quebec from January 29, 1996 to March 8, 2001.

61 The Montreal High Lights Festival is a cultural and gastronomic festival aiming to boost tourism during winter. Proposed by Tourisme Montréal, it was selected as a priority project during the October 1996 summit. Supervision of the event was entrusted to Équipe Spectra, which launched it in February 2000.

62 The first world forum was held in Porto Alegre, Brazil between 2001 and 2005. This forum was intended as an alternative to the World Economic Forum held in Davos, Switzerland. Its goal was to unite citizen-based organizations around the world to create social transformation of the planet.

63 For example, on the front page of *Le Devoir*: "Mais où donc s'en va le maire Tremblay? Le Sommet de Montréal s'ouvre dans un climat de scepticisme." ("Where is Mayor Tremblay Going? The Montreal Summit Opens in a Climate of Scepticism.") Journalist François Cardinal claimed that neither individuals nor pressure groups understood what could emerge from these three days of discussions. (*Le Devoir*, Tuesday, June 4, 2002, p. A1.)

64 Richard Florida, Louis Musante, and Kevin Stolarick, "Montréal's Capacity for Creative Connectivity: Outlook & Opportunities," Martin Prosperity Institute, 2009. A summary of this article is available at www.culturemontreal.ca/pdf/050127_catalytix_eng .pdf

65 See: http://www.culturemontreal.ca/pdf/050318_CM_Amenag Urbain.pdf.

66 The 2007–2017 action plan is available on the city's website at

http://ville.montreal.qc.ca/pls/portal/docs/PAGE/CULTURE_FR
/MEDIA/DOCUMENTS/PLAN_D%27ACTION_2017FINAL.PDF

Conclusion

67 Canadian economist Jeff Rubin predicts the re-emergence of national markets and a forced return to an economics of proximity, notably due to the rise in the cost of oil. See his book: *Why Your World is About to Get a Whole Lot Smaller: Oil and the End of Globalization*, Toronto, Random House Canada, 2009.

68 The most recent data published by Statistics Canada reveal that Canadians donated a total of $10 billion in 2007, which represents a nominal increase of 12 per cent in the value of donations compared to 2004. Close to 12.5 million Canadians or 46 per cent of the population aged fifteen years or older did more volunteer work in the year preceding the study. Canadians devoted close to 2.1 billion hours of volunteer work, the equivalent of close to 1.1 million full time jobs, which represents in hours an increase of 4.2 per cent compared to 2004. See http://www.statcan.gc.ca/pub/71-542-x/71-542-x2009001-eng.htm.

69 Jane Jacobs, *Dark Age Ahead*, New York, Random House, 2004, p. 173.

70 *Ibid*.

71 Guernica, which gave its name to one of Picasso's most famous paintings, is the historic capital of the Basque country. It was bombarded on April 26, 1937 by Hitler's air force, supporting General Franco during the Spanish Civil War, and 3,000 of the city's 7,000 inhabitants perished. Picasso, like many other artists, was revolted by this carnage of the civilian population.